LONDO

STREET SCENES O

1960–1989

ROBERT HALLMANN

In memory of my father, whose simple box camera started me off on a lifetime's passion, and of Maureen for her infinite patience.

Ever Changing, Evolving, Surprising, Fascinating, Inspiring London

The streets and alleys and grand vistas. The traditional and the quirky. The heroic statue and the tramp. Veteran cars on Westminster Bridge. Working horses in the park. Bustling markets. Opulent shopping. Changing fashions. The first 'mini'. Street life reflected. Pageants and pigeons. Queen Elizabeth II riding side-saddle in the Mall. Neon lights of Piccadilly. Music at St Paul's. Punks in the King's Road. Tourists at the Tower. Leafy Victorian cemeteries. Lovers and entertainers. Christmas in Trafalgar Square.

For more than four decades one man and his camera collected images in London. A small-village boy in awe of the variety and the surprises of the big city …

First published 2015

Amberley Publishing
The Hill, Stroud
Gloucestershire, GL5 4EP

www.amberley-books.com

Copyright © Robert Hallmann, 2015

The right of Robert Hallmann to be identified as the Author of this work has been asserted in accordance with the Copyrights, Designs and Patents Act 1988.

ISBN 978 1 4456 4562 9 (hardback)
ISBN 978 1 4456 4570 4 (ebook)

British Library Cataloguing in Publication Data.
A catalogue record for this book is available from the British Library.

Typeset in 11pt on 12pt Sabon LT Std.
Typesetting by Amberley Publishing.
Printed in the UK.

CONTENTS

INTRODUCTION

I came to London with the same blissful innocence with which I had left my native Germany, first to a printing house in Holland and then, in 1956, to Wales, then England and eventually Dublin, a traditional typesetter by training on a quest to widen my knowledge. Blame the curiosity of adventurous youth with only a few words of English for crossing the water.

Passing through from one job in Holland to another in Wales, I had one spare day in town in 1956, so I jumped on a big red bus and somehow asked the conductor to drop me off somewhere of interest. I found some of the most iconic sights that day and although I usually only spared one image per scene, I managed to use up two films. Later I developed my own, but films, developing and printing were expensive then.

Eventually the lure of the big city won and I settled in London's Mayfair as typographer in an advertising agency, for a while at least.

There had been many misconceptions about London – or should I say opinions? One mariner friend had warned me I would not be able to find my way around because of the constant fog. Some of the prior knowledge came from popular fiction. The notion of mist swirling around gas lamps in dark alleyways, damping the sound of hoof, wheel and heel on pavements or echoing eerily across the Thames was a favourite one. The lone stalker, predator or hero pursuing his grisly quest by moonlight among crowded tenements, or the ingenious all-solving detective with eyeglass, pipe and deerstalker pronouncing in dark aspidistra-filled parlours, were part of an ingrained perception of London. Obviously the stories were echoes of Jack the Ripper and Sherlock Holmes, peppered with knickerbockers and riding boots, deerstalker and bowler hats, not forgetting the inevitable umbrella.

On the whole, such preconceptions were benign, interwoven with a shot of mystery, individuality and even idiosyncrasy, it seems in hindsight.

As for the smog, I did still see people wearing white face masks while waiting on an Underground station platform. But London was improving and the air, and later the Thames, even, were getting cleaner.

Commuting daily and eventually freelancing in the West End from Essex, some parts of London became familiar routes. Sometimes it meant walking east to west and back during tube and bus strikes, when the streets were clogged with cars and taxis became unavailable – or if they were available it was likely that a brisk walk would get there ahead of any transport.

Still, there were times to explore when work allowed, or when special occasions demanded. London became a backdrop to scenes that never lost their mystery. Following the tourist trail, exploring the history, the pageants, the arts, the river, the markets, the fashions, the people …

Travel by bus or Underground and you'll meet the world – sandalled monks and stiletto-heeled damsels, heavies in chains and bovver boots and rouges on platforms. Some fellow passengers would pray for your soul and some would prey on your good nature. I was caught out once, when somebody just 'bumped' into me while stepping onto a big red bus; I later found my wallet missing. Such is the mix of Londoners that, while the money had vanished, hurriedly discarded documents were found and posted back to me and credit cards were handed in to a police station.

People who were 'casually hanging out' near busy conurbations might suddenly jump into action when they got the call and we'd witness a chase after a pickpocket or some other misbehaver. A gallery worker might chase out into the road and yell after a fleet-footed thief who ran past before one could even react. Further along somebody would make a citizen's arrest when a framed picture fell out from under a tightly clasped garment.

Contrary to today, there were few eating places in Oxford Street in my early days. An Aberdeen Steakhouse and Lion's Corner House at Marble Arch are all I remember. Leaving the main thoroughfares for the lanes and alleyways was where surprises could be found. The City had few shops apart from markets like Leadenhall, though there were an Austin Reed and a Moss Bros store close to Fenchurch Street to help keep up appearances.

London remained a wonderland even throughout the struggles of surviving in a demanding and competitive environment. A camera was rarely far away, resulting in exhibitions, publications and even coffee-table books. Illustrating a variety of books from antiques and falconry to landscapes, I once spent the entire fee received for one particular effort on a plate camera to take the photos for the colour plates.

I took a mono print of a young girl in a demure short-sleeved top clasping a daisy to the *Daily Mirror* offices in Fleet Street and I was taken across the road into a noisy, clanking, busy, printing-machine-overwhelmed world where the hands-on editor accepted my offering on the spot. Some months later I returned with another print of the same young lady in hot pants and the walk into the cavern that was the printworks was repeated. Again the editor printed my picture and the young lady was on her modelling way. She has since mentioned my help in her autobiography.

Youth became vocal and pushy, not least in advertising – it

was a young person's world. I was asked to photograph cars and car interiors by a major motor distributor. The chap who had engaged me was introduced as their 'whizz kid'. Everybody needed one.

At a well-known security manufacturer, the young man in charge of publicity engaged my design services because he put great value on helping young people stand on their own two feet.

In 1979 I got an offer to illustrate a tome on antique toys and dolls. In 1982 my pictures on falconry were accepted and allowed a young lady falconer to write her first manuscript. In 1984 two large-format picture books lauded the landscape of Britain and coastal Britain. They gave me the excuse to travel the country from the Orkneys to the Isle of Wight. I hired little Cessna planes to photograph archaeological sites that make more sense when seen from above, and I climbed England's highest mountain, Scafell Pike, when it was capped in snow and I have rarely felt so utterly alone and proud.

Camera magazines vied for readers and contributors and I won cameras and equipment in national and international competitions. Even my Hasselblad was acquired that way. A month-long exhibition of colour photos just off Regent Street and a portrait exhibited in the National Portrait Gallery belong with my fondest memories.

All this enthusiasm stemmed from a primitive early device, the Agfa equivalent of Kodak's Brownie. My father's Agfa box camera survived the destruction of the war in the spring of 1945 in the cellar of our burning house, when artillery fire and phosphor grenades set much of our village alight, and we fled into a telephone-wire-tangled road. I was ten years old when the final battles of the Second World War passed through our village. The camera was the only thing that remained in the charred ruins apart from a (stone-hard) cake and a few darkened clothes.

I had the simple safety-pin spring mechanism repaired at a watchmakers and was lured into a hobby that retained its interest throughout the years and through several more cameras.

Can one ever get tired of the energy and the variety of a town that even has a City within the city? Collected here are three decades of London and Londoners – one man's vision and memories. Daytime, night-time, summers and winters, there is constant change in the multi-coloured, ever-active vitality that is LONDON.

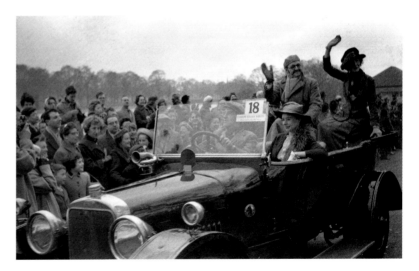

1

MEMORIES OF THE 1960S

The 'sixties' have been called the decade of rebellion, when 'peace and love' became household words – banners of lifestyle. Hippies wore flowers in their hair and made love rather than war. Clothes became colourful – peasant-style blouses, psychedelic prints, batik fabrics and paisley patterns, hipsters, culottes and bell-bottoms.

On the jukebox, Chubby Checker taught young people to twist individually.

Mary Quant raised the hemline (and the blood pressure for some) and the mini became the fashion. As the skirts moved higher, the boots followed; knee-high white leather was the 'in' thing. Large bug-eyed sunglasses and pillbox hats a la Jackie Kennedy became popular. Audrey Hepburn wore drainpipe jeans.

Men's hair grew longer and moustaches droopier as trouser bottoms widened. The London Modernists or 'Mod's shaped their own popular trends in anoraks and bespoke tailored Italian suits while taking to scooters as their preferred mode of transport.

The Design Centre in the Haymarket encouraged and supported enterprise and talent throughout the sixties, seventies and eighties, helping to shake off the residue of the plain, utilitarian living styles of the war years, bringing fun, colour and excitement to life, as well as encouraging commerce. Young designer friends experimented, invented and added zest to their world. The Design Centre became a shop window for British design, and its label affixed to product or packaging would encourage and support good design for several decades. It was like an awakening, a surfacing from a long period of drabness. Young people found their voices, embraced their own styles and followed their own creativity.

The London Tourist Board was created in 1963.

French President Charles de Gaulle vetoed Britain's application to join the European Common Market, saying the British Government lacked commitment to European integration. They still do.

There were political upheavals. Founded in the late 1950s, 'Ban the Bomb' marches by the Campaign for Nuclear Disarmament

really took off in the 1960s, when it seemed the world was heading towards instant self-destruction. Prime Minister Harold Macmillan told us we'd 'never had it so good'.

In 1964 Labour won the general election and Harold Wilson became Prime Minister. In 1965 the death penalty was abolished, and in July 1966 England won the World Cup at football against Germany.

The Beatles had taken the musical world by storm and such was their influence and genius, in June 1967 even I began buying records like 'Sgt Pepper's Lonely Hearts Club Band', even though my own leanings are towards the classics and jazz. Pop music grew up for a while and became serious fun.

As for the 'swinging' and the psychedelic era, I saw very little of it. We talk of the 'Swinging Sixties', meaning the 'progressive youth-centric cultural scene' in London at the time, though if it had not been for my occasional photographic sojourns, while being busy and building up a clientele and a reputation, the notion of 'Swinging London' would have largely passed by unnoticed.

In March 1969 the world's fastest passenger plane, the British–French cooperation Concorde, made its maiden flight, though the first paying passengers had to wait until 1976. The world's 'jet set' no longer relied on jets; they could now speed around the world on its first and to date only commercial supersonic airliner faster than the speed of sound.

A Mayfair Beginning

My introduction to London was in the genteel, if exclusive, realm of Mayfair. Having presented myself to one of the directors of an advertising agency, the conversation involving my training and experience took on a worrying turn: 'Germany? I was torpedoed by the Germans!' My heart sunk; though that had not been my fault, one could not be surprised at such a reaction. However, it was just a factual comment. Once I had convinced the firm's senior typographer that I knew my typefaces and type sizes I was engaged. London had accepted me.

One of my graphic-designer colleagues was a tall, blond, Germanic figure. On occasions when we passed that particular director on our way out or back on the wide and sumptuous Edwardian staircase, he would address that young man with, 'Well, how are things in Germany, old boy?' I was always amused by the young man's annoyed answer: 'I'm not the German …'

The building with large rooms and high ceilings, like most of the offices in the area, had once been a family town house. Even in our salubrious studios a copying or duplicating machine might be placed on a securely covered ornamental bathtub in a small room.

Telephone numbers still began with the proud prefix 'MAY' for Mayfair. Roads were narrow enough that telephone numbers writ large on sheets of paper and pressed up to windowpanes might return the desired acknowledgement from typists and office girls opposite.

Not far to the west on Park Lane stands the London Hilton, and racing driver Sterling Moss just had a pad built in the neighbourhood, shielded by an imposing ornate wrought-iron fence. A colleague needed a sales image of neckties, so he just went out to 'Sterling's fence' to display and photograph them.

Closest to that imagined Fair of the May came Shepherd's Market right at the end of our road. The somewhat misleading

name actually refers to one Edward Shepherd, its eighteenth-century developer. There had been, however, an infamous fifteen-day fair held on the site since James II in the 1680s that gave its name to the wider area. In spite of its eighteenth-century gentrification, Shepherd's Market still had some of the charm of a village about it, with touches of both the nice and the naughty. Locally it's referred to as 'The Heart of Mayfair'.

Even in daylight business ladies of the night might lean out of some first-floor window about the market area, discreetly as if by accident dropping an unfinished cigarette or some ash just ahead of a passer-by, with a whispered 'Hullo, Deary!' If the so-addressed gent looked up in surprise he would be met with an endearing come-hither smile.

One of my lasting mysterious conundrums was a certain basement flat in nearby Curzon Street, where a red, neon sign advertised 'French lessons' to the passer-by above, who looked down into a well-appointed room where a relaxed lady could be observed quietly engaged in knitting.

A group of us, graphic artists, typographers and the odd accountant, would enjoy our lunch breaks in one of the several eateries in the area. Lunchtime was a chance for exploration, a kind of culinary quest – not for the most expensive, but the most original and interesting.

'I know a place where they still have tiles on the walls and sawdust on the floor and they only serve "chips with everything …"'

It was amazing how some establishments would manage to cater for the sudden lunchtime rush on several floors of a house that once would have been a family home with servants living in the attics. Dumb waiters took much of the food and tableware between floors, when every spare square foot from the basement up was brought into use as seating/eating areas. Waiters and waitresses on the narrow stairs had to be both steadfast and agile, qualities that might be required of the diners as well. But then we were young; older generations would frequent more salubrious establishments. As well as a cinema there was one of the most expensive shaving emporiums in nearby Curzon Street.

Tiddy Dols was an intimate basement where cellars and underground tunnels crammed full with tables and benches and lit by wax-dripping candles in straw-braided Chianti bottles caused even strangers to huddle together closely, thus almost forcing joviality and conversation. Red-and-white gingham tablecloths, cock-a-leekie and mulligatawny soups and the 'best summer pudding in London' spelled ambiance. Standing upright in the side tunnels was impossible because of the curvature of the roofs that reached out under the streets, where once coalmen would have tipped the contents of their black sacks down chutes into the cellars of private residences.

In South Audley Street, just down from and opposite the eagle-protected American Embassy, was the underground car park of the Indian Embassy. It was a passageway to the embassy's own staff restaurant, where excellent traditional curry dishes were available to all visitors at most reasonable prices. For the culinary explorers of the time it was all part of searching for variety, the original and genuine. Later one might even take a lift to the staff canteen at the BBC off Great Portland Street unchallenged.

At one time we were advertising 'chips' for use on breadboards and in television cameras. Those were exciting times. I never knew what those chips were or did, which perhaps proves that one does not necessarily need to know what one is talking about in advertising.

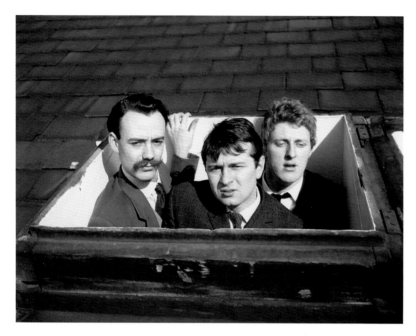

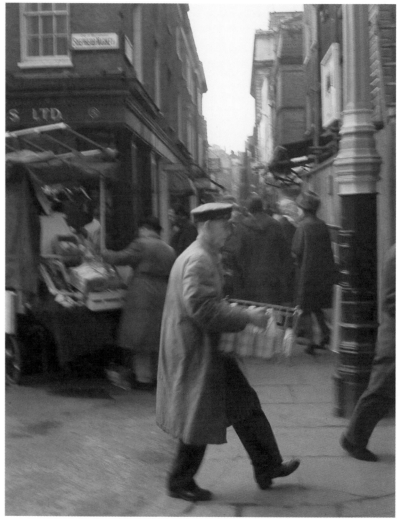

Above: Colleagues on the roof of the Mayfair advertising agency. I very much doubt such lunchtime cavorting would be allowed today. When the agency moved out, the premises became a foreign embassy.

Right: Shepherd's Market milkman, early 1960s.

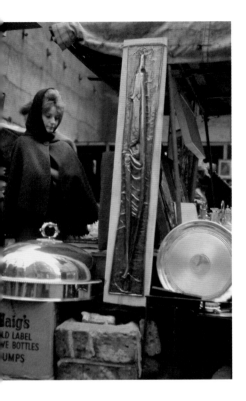 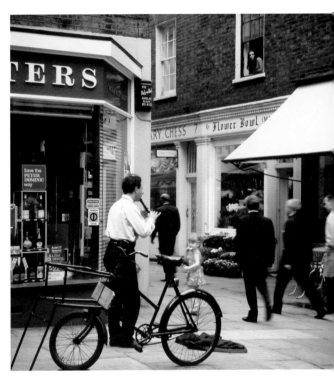

Above left and middle: Shepherd's market: a genuine small market of art and artefacts, still unpretentious. One of our favourite stalls was an antique/art establishment manned by a young lady in cape and headscarf and with a quietly elegant demeanour.

Above right: A Pied Piper of Mayfair.

Boudicca's Revenge

Boudicca has become a symbol of the fight for freedom from oppression and domination. Her husband Prasutagus, chief of the Iceni tribe of East Anglia, died in AD 60 under the Roman invasion. His agreements with Rome were ignored, his wealth was ceased and his wife and daughters were raped and humiliated. Boudicca took charge after that, and with her army of Celts she took a terrible revenge, burning and devastating first Colchester and then Londinium, leaving no survivors. She moved on to sack St Albans, but Rome's superior forces were victorious in the end.

Like so many tourists, I took in the sights together with a colleague. I wanted to capture the people naturally, but focussing wasn't easy with those early cameras. I asked my colleague to hang back so I could focus on him and people would ignore me. It worked, though he somewhat overacted in his slouching casualness.

In the background, across the river, County Hall was still the headquarters of local government for London. In the 1980s it became a bone of contention between Ken Livingstone's Labour-controlled GLC (Greater London Council) and Mrs Thatcher's Conservative government across the water the other side of Westminster Bridge. The modern-day Boudicca won: the GLC was abolished and eventually County Hall was sold off into private hands.

Right: She once utterly destroyed London, merciless and in unabated fury. Boudicca rides still, arms outstretched on her chariot, accompanied by her maltreated daughters, towards the Palace of Westminster. Is she outraged at some dastardly Act of Parliament or at some overzealous demand of taxes or curtailed privileges?

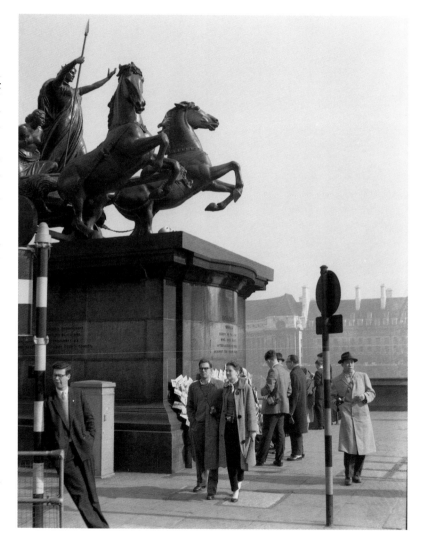

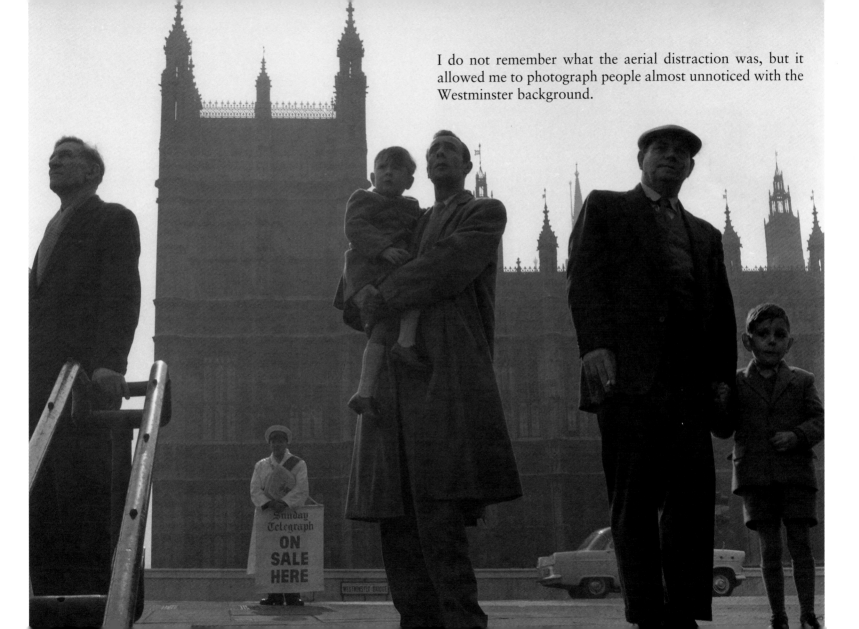

I do not remember what the aerial distraction was, but it allowed me to photograph people almost unnoticed with the Westminster background.

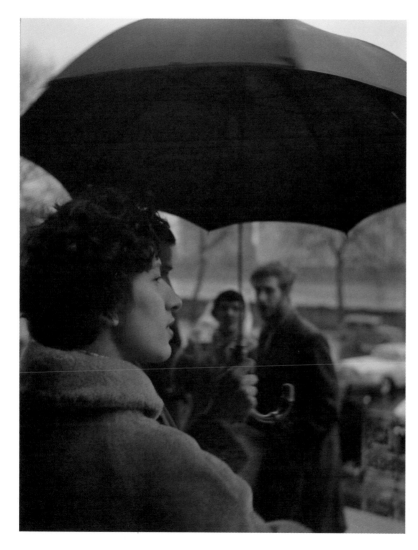
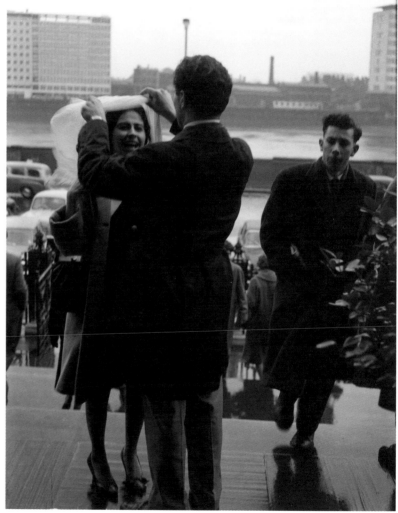

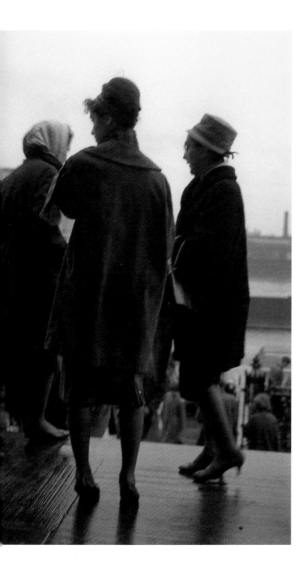

Previous and this page: Rainy day on the steps of Tate Britain, Millbank, then the Tate Gallery with a view of the Thames. I enjoyed photographing visitors coming or leaving the site that once was the Millbank Prison.

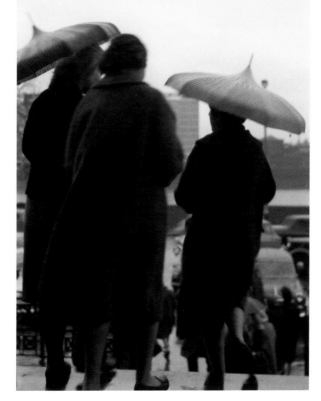

The Brighton Run on Westminster Bridge

The Royal Automobile Club organises the early November Sunday morning assembly in Hyde Park of cars eligible only if they were built pre-1905; the 1953 film *Genevieve* helped popularise the run. It has taken place every year except the war years and during petrol rationing. In the centenary year of 1996, 680 cars took part.

Whitehall

From 1530 until most of it burnt down in 1698, Whitehall was the main royal residence. It was so extensive it had become larger than the Vatican or the Palace of Versailles with 1,500 rooms. Among other alterations, Henry VIII added a pit for cock fighting. That venue now houses the Cabinet Office at 70 Whitehall. Horse Guards Parade used to be his tilt yard for jousting tournaments.

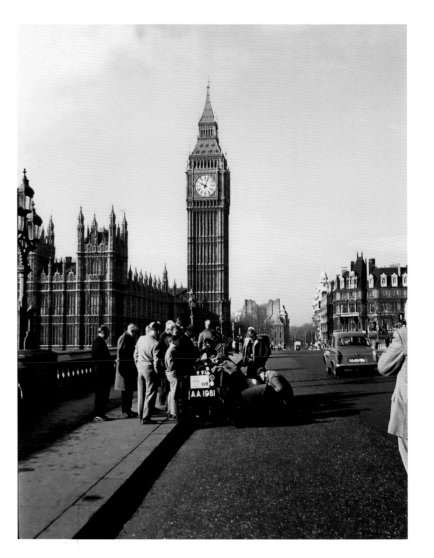

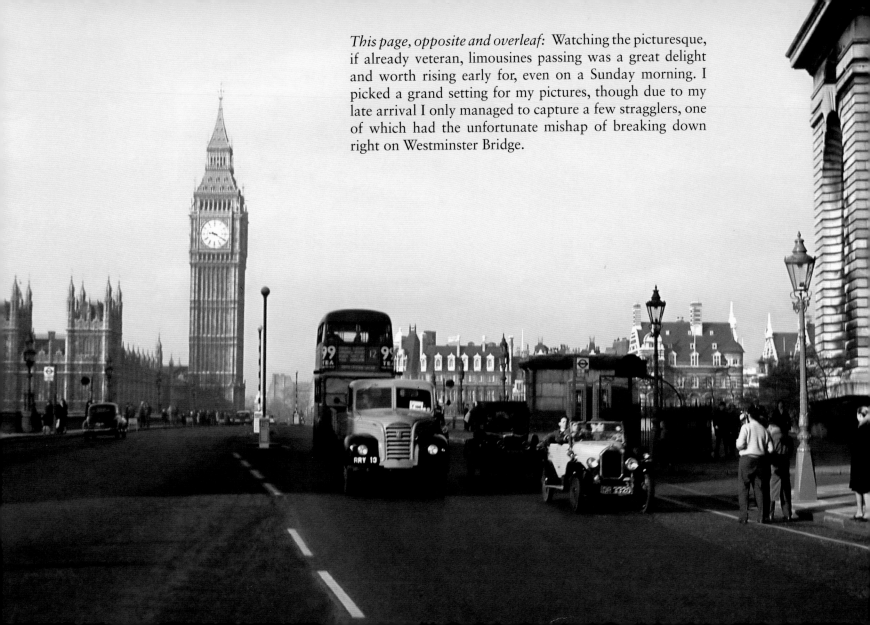

This page, opposite and overleaf: Watching the picturesque, if already veteran, limousines passing was a great delight and worth rising early for, even on a Sunday morning. I picked a grand setting for my pictures, though due to my late arrival I only managed to capture a few stragglers, one of which had the unfortunate mishap of breaking down right on Westminster Bridge.

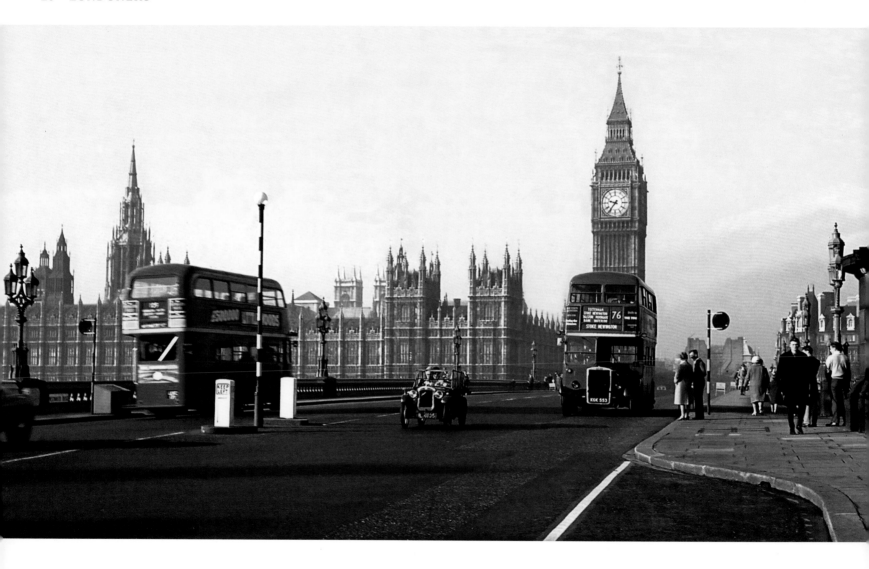

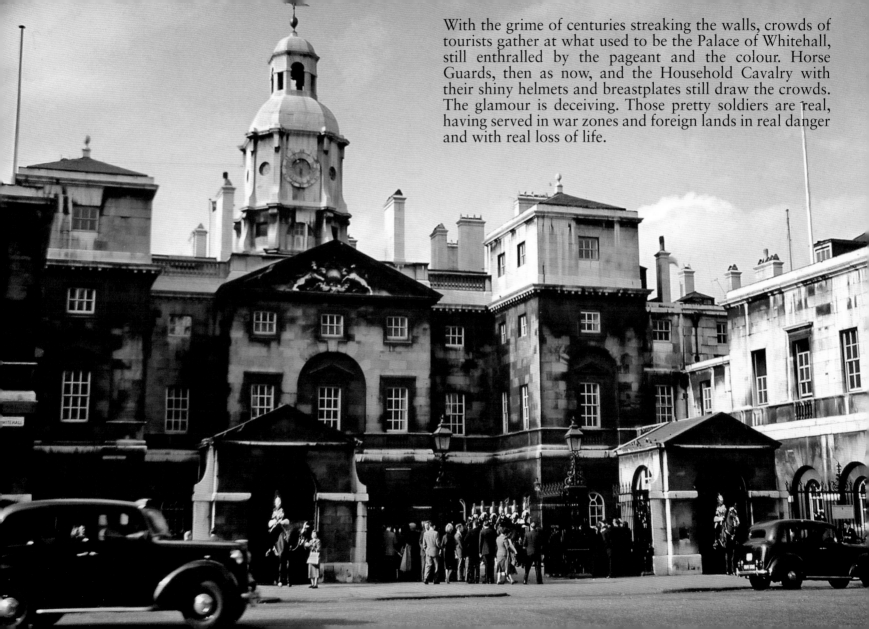

With the grime of centuries streaking the walls, crowds of tourists gather at what used to be the Palace of Whitehall, still enthralled by the pageant and the colour. Horse Guards, then as now, and the Household Cavalry with their shiny helmets and breastplates still draw the crowds. The glamour is deceiving. Those pretty soldiers are real, having served in war zones and foreign lands in real danger and with real loss of life.

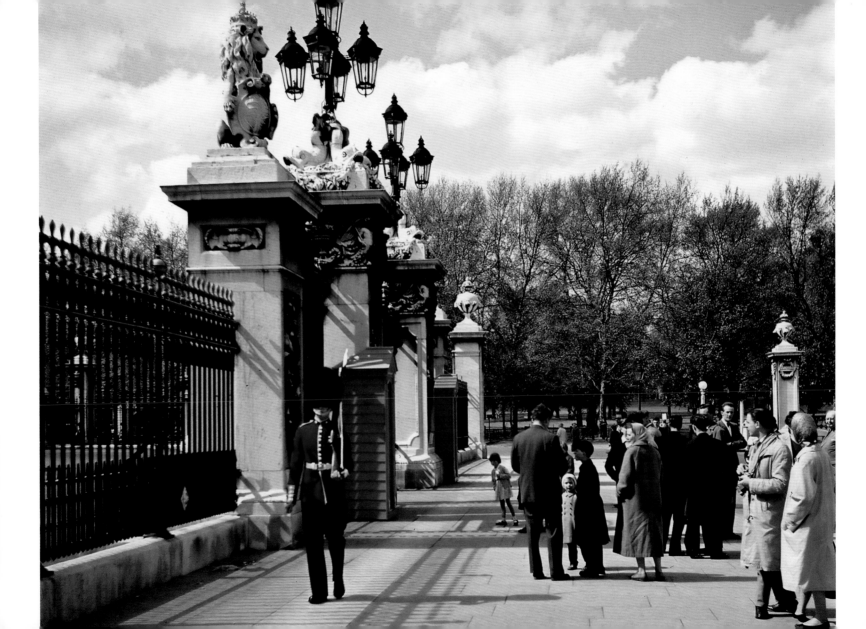

Opposite: Buckingham Palace

A picture from the late 1950s, just before the guardsmen retreated out of harm's way. They have changed guards at Buckingham Palace behind the railings since 17 October 1959, when a sentry of the Coldstream Guards accidentally, or perhaps on purpose, kicked the ankle of an overly familiar female tourist while stomping and marching out his exercises. The police were called, a complaint was made and the sentry was confined to barracks for ten days. (In 1982 an intruder managed to evade sentries at Buckingham Palace and enter the Queen's bedroom before he was arrested by police.)

St James's Palace

Built in the early 1530s by King Henry VIII, on land once belonging to the leper hospital dedicated to St James the Less, as a smaller version of Whitehall Palace to escape from court life. Whatever happened to the lepers?

When the large Palace of Whitehall was destroyed by fire in 1698, St James's became the principal royal residence for over 300 years. Future kings and queens were born here. It was from here that Elizabeth I left to encourage her troops at Tilbury; Charles I spent his last night here; and Oliver Cromwell, for a while, turned it into a barracks. St James's is still the sovereign's official residence, although since Queen Victoria all royals have lived at Buckingham Palace.

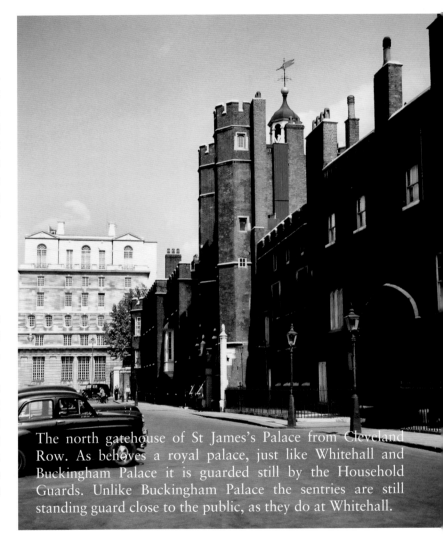

The north gatehouse of St James's Palace from Cleveland Row. As behoves a royal palace, just like Whitehall and Buckingham Palace it is guarded still by the Household Guards. Unlike Buckingham Palace the sentries are still standing guard close to the public, as they do at Whitehall.

Piccadilly Circus

Created in 1819 at the junction of Piccadilly and Regent Street, Piccadilly Circus became something akin to the centre of London, if not the world. During the Second World War, the proliferation of prostitutes and American servicemen had been in danger of threatening Anglo-American relations. Even in the 1960s women could still be found soliciting in doorways in nearby Soho Square.

During the war years Eros was replaced by advertising hoardings. In the 1980s, as part of a pedestrianisation scheme on the south side, the statue and fountain were moved sideways out of the centre of the Circus.

Right: To the newcomer, the area around the Shaftesbury Memorial Fountain, better known for its statue of Eros the Messenger, with its brash, outsize and flashing neon adverts spelled a kind of colourful if tawdry wonderland at night. Eros can just be seen centre right, here in 1960. Without the use of a tripod, it might mean pressing the camera tightly against walls or street furniture for steadiness during the long exposures required.

Opposite: On another occasion I went out especially on a rainy night to include the reflections in the wet road surfaces.

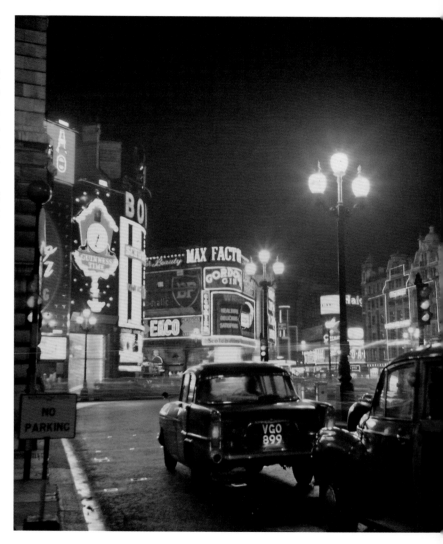

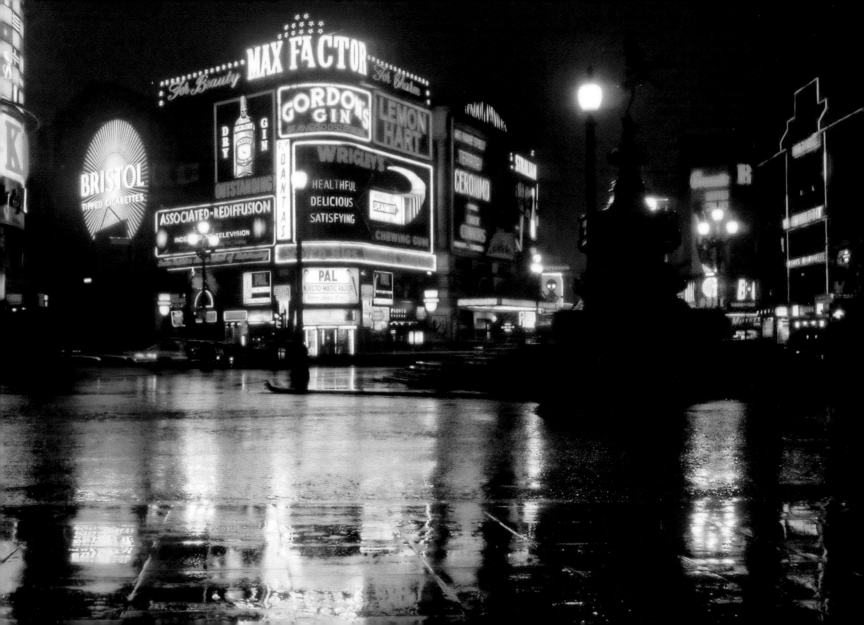

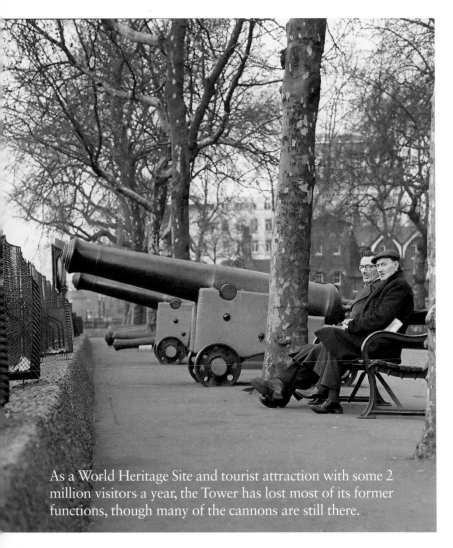

As a World Heritage Site and tourist attraction with some 2 million visitors a year, the Tower has lost most of its former functions, though many of the cannons are still there.

Old Cannons at the Tower

Built by a conqueror as a statement of intent that he was here to stay; unlike the Romans before him, he did. William, Duke of Normandy, defeated King Harold II in 1066 at the Battle of Hastings and he and his Normans managed to subdue the country by systematically replacing the upper layers of society with friends and relatives. To do that and keep a population under control he built a series of castles, of which the imposing White Tower was the most important.

Henry III enlarged the premises and made them more comfortable. He himself did not spend a great amount of time here, but diplomatic gifts from other rulers did – lions, an elephant and a polar bear among them. I have witnessed jousting by knights in full armour in the moat.

Edward I, the Hammer of the Scots, moved the London mint to the Tower and it became a keep for prisoners. Kings and queens have been imprisoned and murdered here.

During the Civil War the Tower, as all of London, fell to Parliament. Cromwell had the Crown jewels destroyed and sold off, though new ones were displayed at the Restoration of the monarchy, and among other institutions the Tower became the Office for Ordinance.

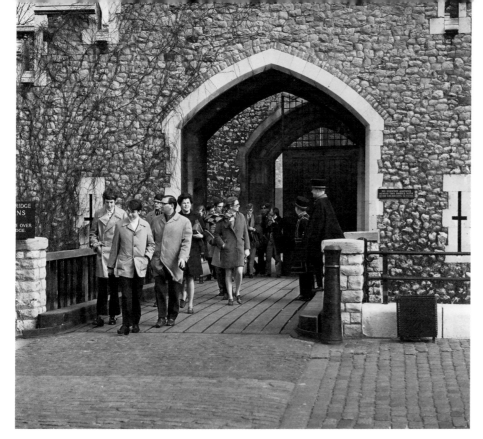

Above left: Beefeaters guide, shepherd and advise the visiting public still.

Above right: Even on a dull day in the 1960s, the Tower, the Thames and Tower Bridge were magnets to visitors.

Right: Across the river the commercial buildings and warehouses of the Pool of London have seen better days.

The Demise of the Pool of London

'The old warehouses on the Southbank: find them before the developers do', or words to that effect, urged an advertising slogan on the London Underground. The Pool of London to either side of Tower Bridge had been the busiest section of any river in the world during the expansion of the empire and the Industrial Revolution. Ocean-going vessels brought exotic goods from all around the world and skiffs supplied the growing town with fish. Barges brought farm produce and hay for London's horses. Colliers brought coal from Tyneside. The Thames was just a forest of masts.

In the eighteenth century London's riverside had filled with imposing warehouses. To add more capacity and also to increase security, off-river docks were built. By the 1970s their time was past. Shipping containers needed deep-water coastal ports.

Those docks have become the new Docklands commercial and residential centre. Some of the riverside warehouses, modernised and adapted like Butler's Wharf and Hay's Wharf, survive on the south side of the Upper Pool west of Tower Bridge. Substantial redevelopment took place in the eighties and nineties.

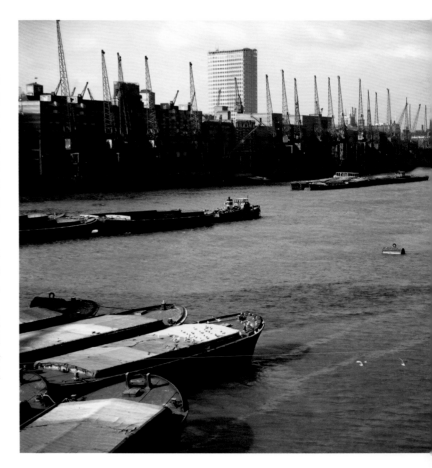

The cranes that emptied the ships from all around the world became useless and stood idle. At the funeral of Winston Churchill on 30 January 1965 the cranes dipped in salute as the lead-lined coffin passed along the river from Tower Pier to Festival Pier.

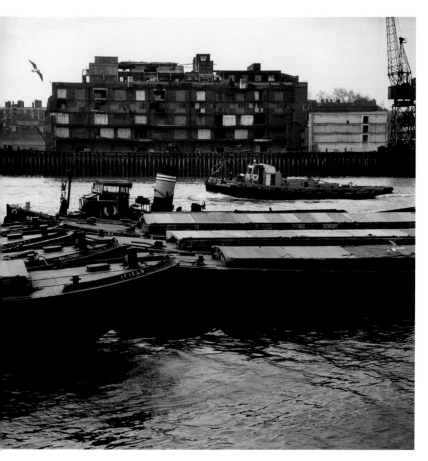

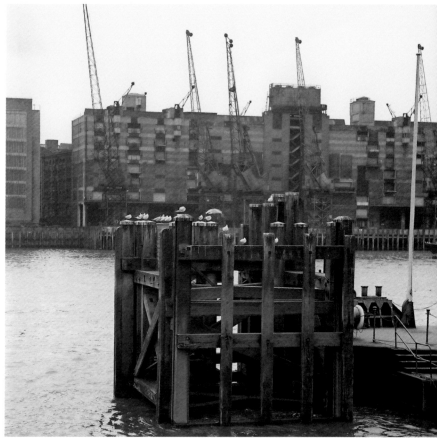

Above left: Southbank buildings were in a pretty dilapidated state.

Above right: The only life here in the once-busy port is a flock of seagulls (*c.* 1969).

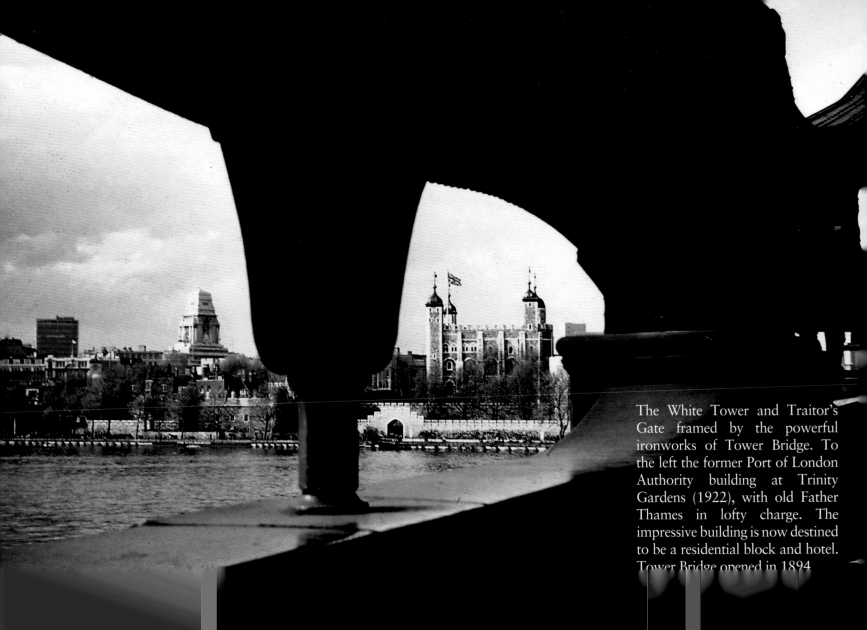

The White Tower and Traitor's Gate framed by the powerful ironworks of Tower Bridge. To the left the former Port of London Authority building at Trinity Gardens (1922), with old Father Thames in lofty charge. The impressive building is now destined to be a residential block and hotel. Tower Bridge opened in 1894.

Sculpture in the Open Air

Battersea Park, from May to September 1960, was the venue for an outdoor exhibition with forty-two works of art on show in the sub-tropical garden – 'Sculpture in the Open Air'. I was impressed enough to photograph a number of the exhibits: Henry Moore's *Glenkiln Cross*, Jacob Epstein's *Ecce Homo*, Elizabeth Frink's *Spinning Man*, Uli Nimptsch's *Olympia*, Eric Kennington's *Mercy* and Siegfried Charoux's *The Violinist*.

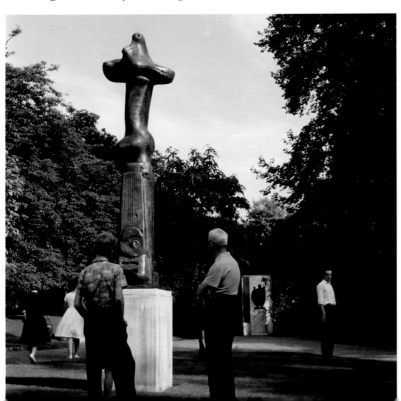

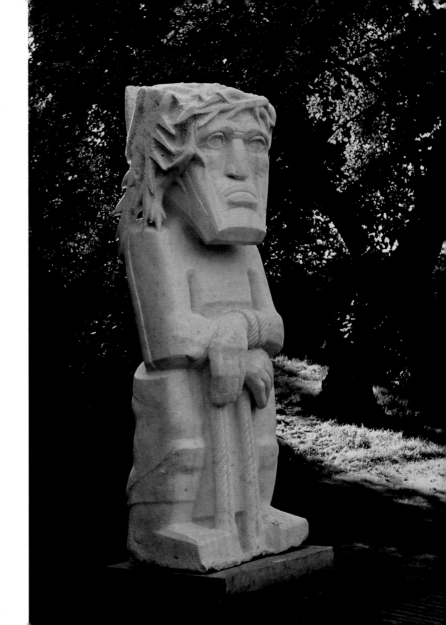

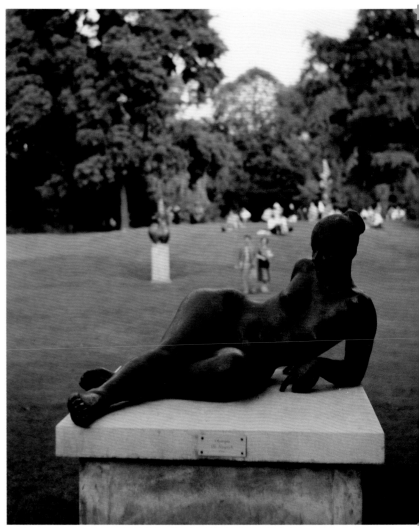

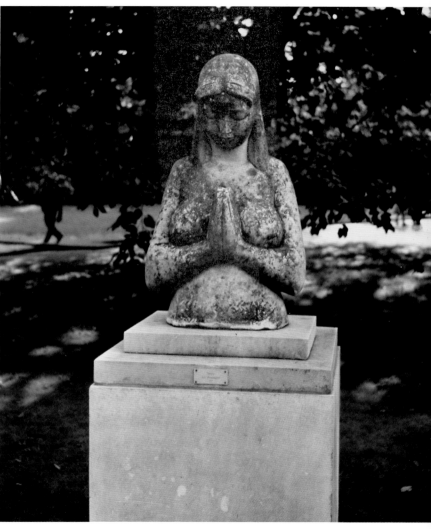

On a Jazz Boat on the River

I had watched the film *Jazz on a Summer's Day* three times at the cinema. Jimmy Guiffre, Thelonius Monk, Anita O'Day, Louis Armstrong … To the jazz lover a Sunday excursion on the river accompanied by the lively blasts was a dream come true.

Opposite: This was the Beatnik generation: flat-heeled shoes, berets, dark glasses, tight capri pants that stopped well above the ankles, but there are also still the little dress and cardigan combinations and headscarves of the 1950s among the audience.

Below: With Cannon Street station and the Monument in view, Tower Bridge rose in salute to let us pass.

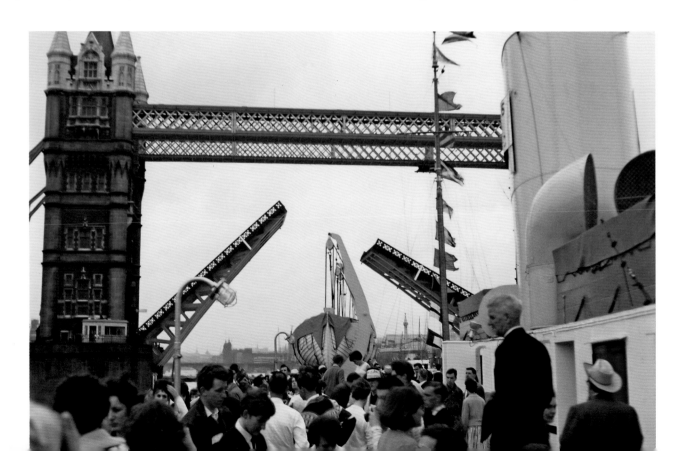

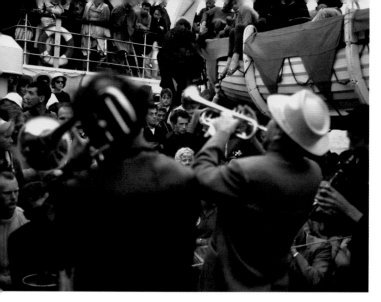
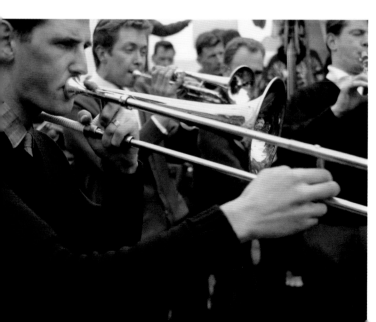
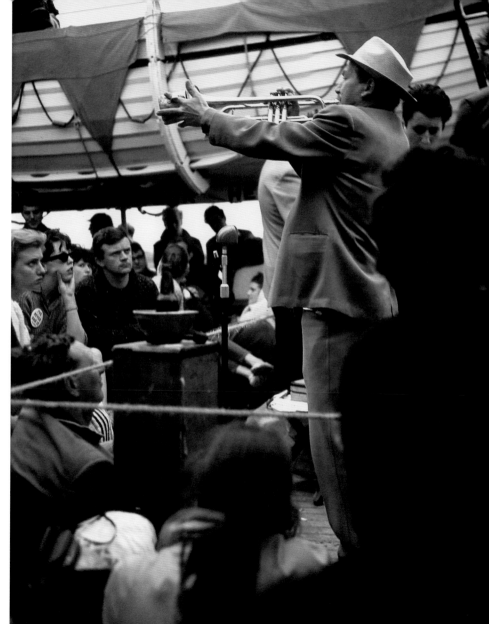

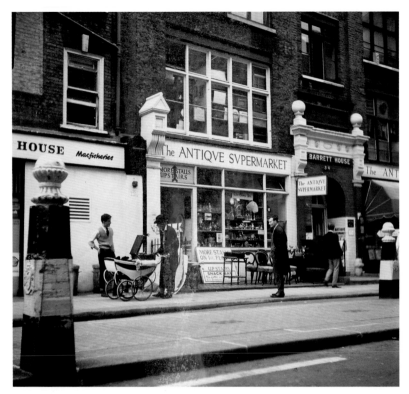

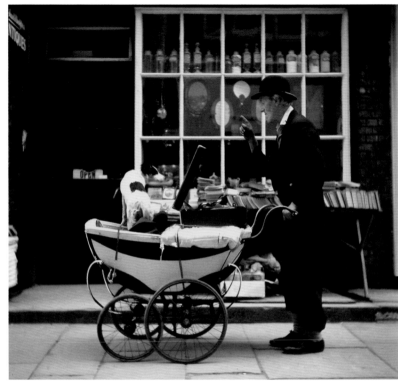

A Hobo in Mayfair

Above left: His Eccentricity, the little man with the old pram, the wind-up gramophone and his dog, was a familiar sight in the narrow streets of Mayfair. He might wind up his gramophone, but I never saw him collect.

Above right: Apart from the antique supermarket in South Molton Street there were lots of little shops in the area, even some that never seemed to change their window displays.

Sloane Square

All that fuss over Sloanes and Sloane Rangers when Diana, Princess of Wales, came on the scene in the 1980s, yet when I went to Sloane Square in the 1960s I found it dreadfully dull. Sir Hans Sloane's eighteenth-century square at the east end of the trendy Kings Road did not show the promise of later notoriety, with its wealthy residents, stereotyped as young upper or upper middle class equestrian enthusiasts, the ladies with silk head scarves tied below the mouth …

Two flower stalls hinting at spring and the inevitable traffic warden left little to be discovered.

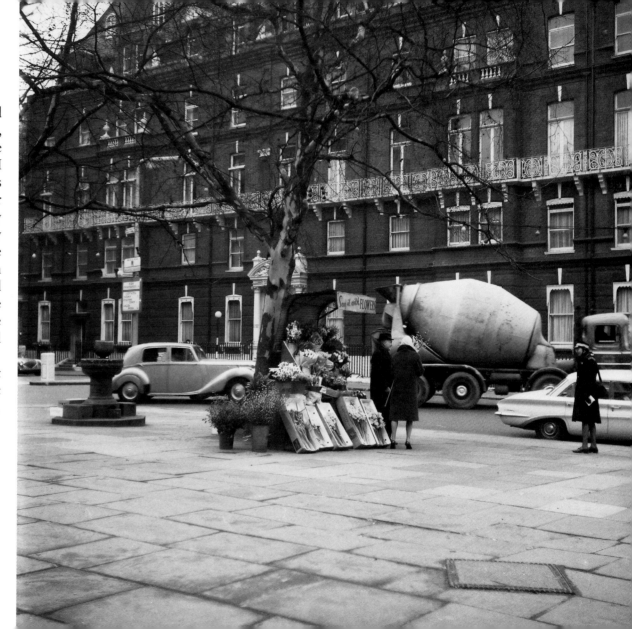

Below: St Giles Circus

As a preamble to a design brief, I went out to look at cars and traffic lights, a good excuse to wander about with my camera. The controversial thirty-three storey Centre Point tower was being erected at the confluence of Oxford Street, Tottenham Court Road, New Oxford Street and Charing Cross Road at the time (1966). It is now a Grade II listed building. Tottenham Court Road Underground is to the right.

Heals store on right with the clock, like Liberty's, was at the forefront of good design, style and quality.

A Shot in the Arm?

Marks & Spencer's store on 258–64 Edgware Road had been completed in 1959. When I took my photo, like many new buildings at that time, it had a sculpture attached to its façade – in this case a stylised male, nude and given a shot in the arm or perhaps struck by a beam of inspiration. No doubt those questionable works of art were meant to enhance the monotony of the new architecture. Already early in 1988 a major refurbishment of the building was instigated. The statue, constructed from a fibreglass material, did not survive; however, an agreement was reached to erect a new statue outside the new building's main entrance. Allan Sly produced the figure of a window cleaner with his short ladder, standing outside the building on Chapel Street NW1, gazing up at the unenviable task the many windows of the huge replacement office block present.

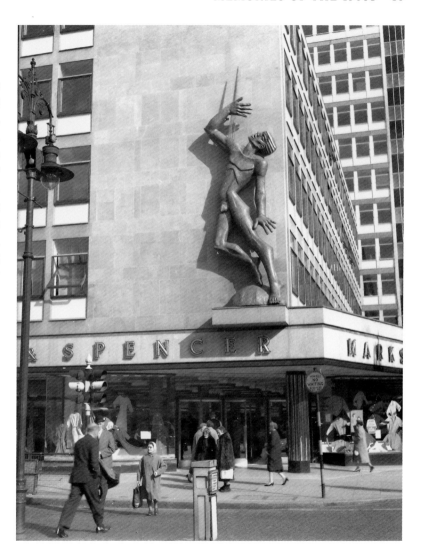

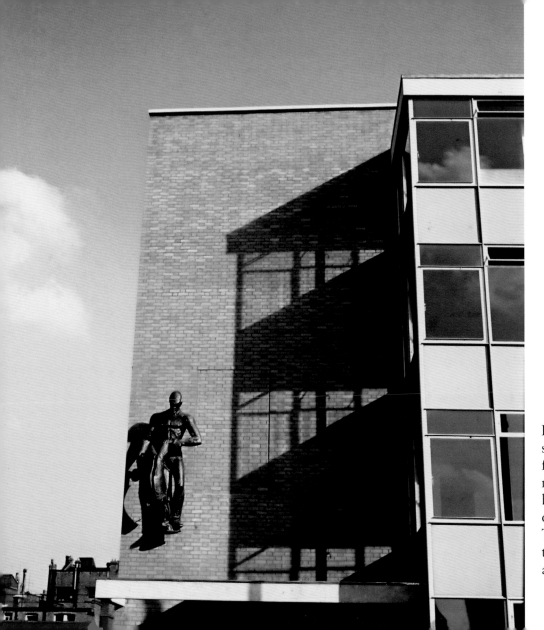

Possibly to offset the blandness of the building style at the time, sculptures, some abstract, some figurative, were placed on strategic points of new buildings. If I remember rightly, this was a block of flats erected on a former meat market or slaughterhouse about the Tower Bridge area. The statue reflected the history of the site, yet there was an outcry about its gruesome brutality and it was removed again by public demand.

Tottenham Court Road and the Post Office Tower

In Tottenham Court Road, near Goodge Street, the somewhat dilapidated wreck of a car caught my interest, seemingly abandoned on the roadside kerb. Alas, in the background the Post Office Tower loomed large. Opened by Harold Wilson in 1965, it was built to carry microwave aerials for telecommunications, standing at 177 metres (581 feet), then the tallest building in London and the UK. In spite of its obvious visibility it was designated an official secret until its acknowledgement under parliamentary privilege in 1993. Even though officially it did not exist it was open to the public for some fifteen years and carried a revolving restaurant on the thirty-fourth floor, operated by the holiday chalet provider Butlins. In spite of its secrecy the Provisional IRA found it in 1971 and exploded a bomb in the toilets.

It's the BP Tower now. It recieved a Grade II listing in 2003, but the restaurant closed in 1980, it is said for security reasons.

Top right: I had been warned not to photograph it. My left hand's vain attempt at blocking out the view to the secret building in the background can be seen in the dark shadow top left.

Moving Away from Fleet Street

The *Daily Mirror* building was brand new in the early 1960s, an alien oversized box on Holborn Circus (EC1), containing the printing presses in the basement; above it rose the offices. Attending evening life classes near Back Hill at the time, I took my camera along and instead of indulging in the noble art of expressing the human form I recorded the monster structure, missing class. The building lasted until 1994, when the Mirror Group Newspapers joined the exit to Canary Wharf in Docklands. Soon afterwards it was demolished. In an ever-changing London the fortunes of a building can change dramatically. The angular edifice was replaced by the large, glass curve of the J. Sainsbury headquarters – for a time at least.

Another Reality

A back alley somewhere near Tower Bridge. Not a colourful flag day, but an ordinary washday, with balconies as outside drying rooms for smalls, not for glorious views.

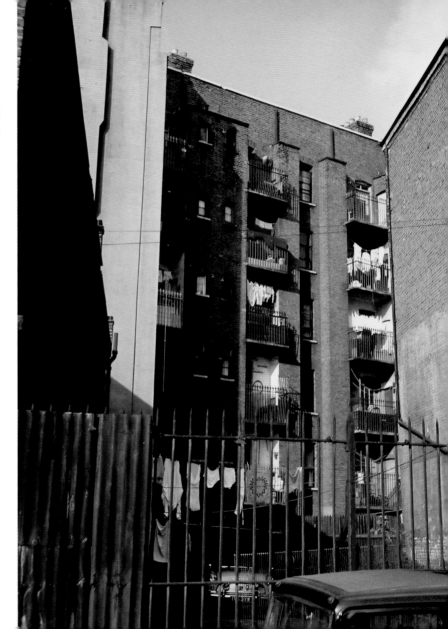

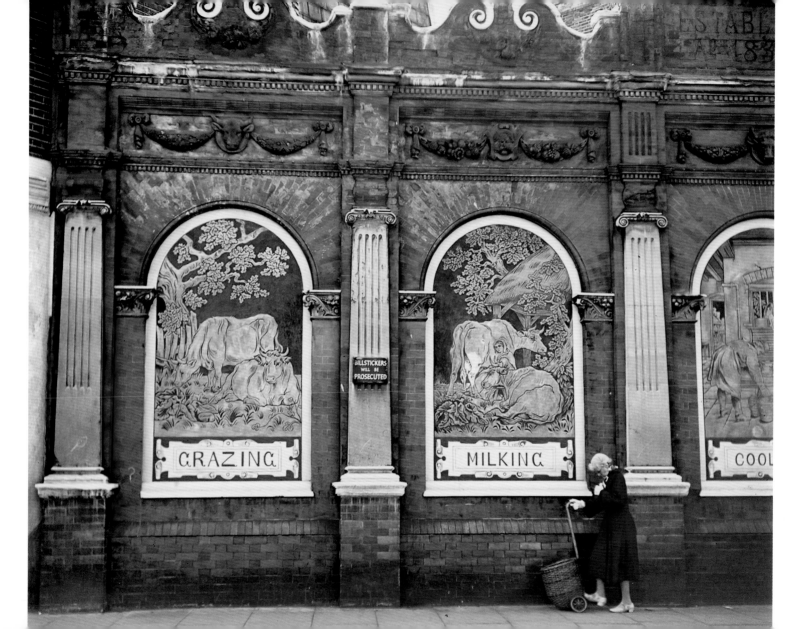

Opposite: A View That Has Changed Little

Once the Friern Manon Dairy, now since 1997 a large gastro pub, Crouch Hill's Old Dairy has retained the stunning friezes of around 1890 on exterior walls. There are actually seven panels, representing the city man's idea of 'very traditional' methods of milk and butter production. In the early 1960s, a friend feared they would be lost to 'progress'.

Right: The Catacombs of Highgate Cemetery

Highgate Cemetery's 'Circle of Lebanon', West Cemetery, looked spooky with its ring of vaults and catacombs that surround a massive Cedar of Lebanon tree, thought to be more than 300 years old. A colleague who lived in the area decided that my camera and I ought to be introduced to some of the highlights of Highgate, where Dick Whittington's cat stoically languished on a plinth beside a busy road, the cemetery and the dairy. When this photograph was taken, in the early 1960s, through cracks in broken doorways, stacked and split coffins with spilled contents could still be observed.

The cemetery has been described as a Victorian Valhalla. Built in 1839, today parts of it are Grade I listed. Some 167,000 people are buried in 52,000 graves so far. There are many famous departed. An outsize bust of the left-wing theorist Karl Marx squats foursquare among the ivy creepers. Born in the German pilgrim city of Trier in 1818 and expelled from Prussia and France, Marx settled in England in 1849, where he wrote *Das Kapital* in 1867.

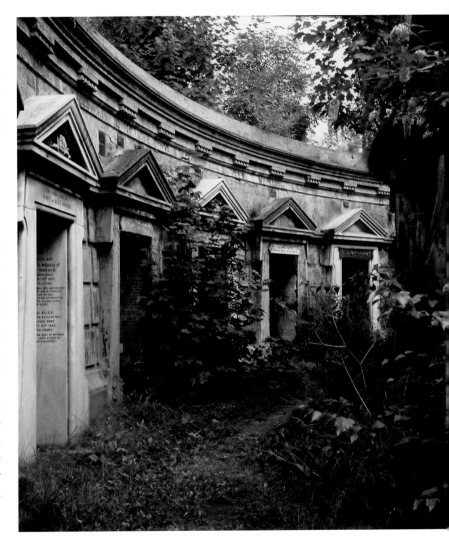

Musical Interlude on Ludgate Hill

An appreciative audience at a lunchtime concert in a sunny Paternoster Square at St Paul's Cathedral, with one of Her Majesty's military bands.

Opposite: The Pageant of Horse Guards

Horse Guards seen from Whitehall with mounted members of the Household Cavalry, as always with tourists in attendance. The view is down Horse Guards Avenue towards Victoria Embankment and the river.

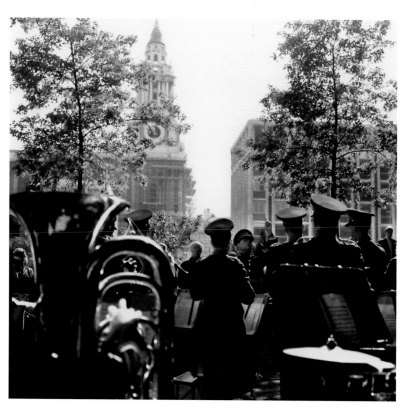

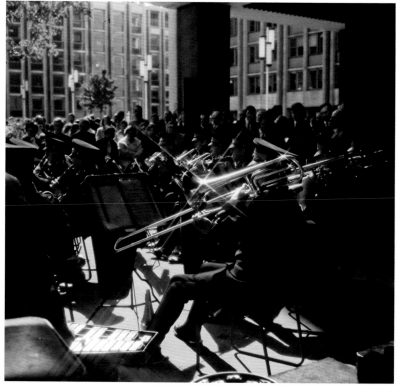

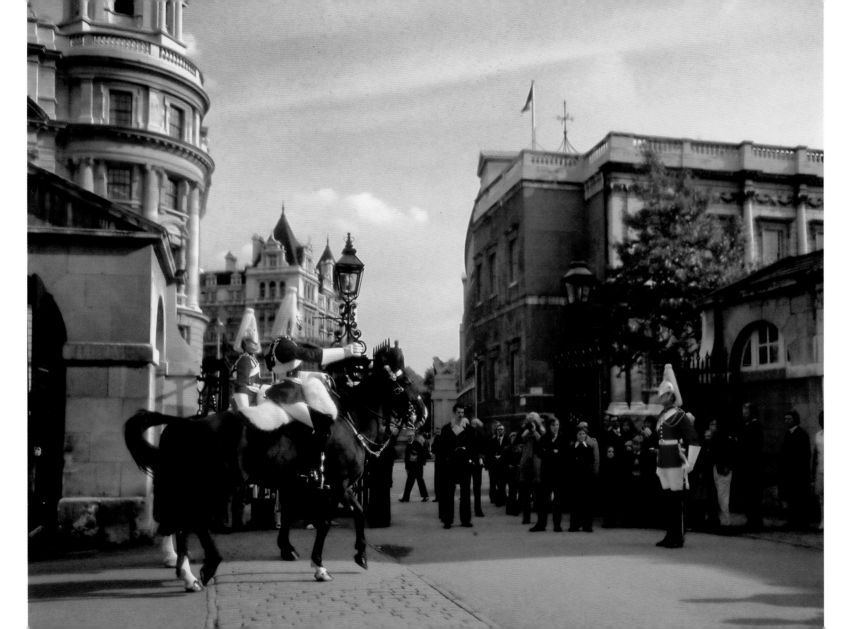

Westminster Abbey

A history that reaches back over a thousand years of daily worship. St Peter's even features on the Bayeux Tapestry. Kings and queens were crowned here – every coronation since 1066 took place in the abbey. Seventeen monarchs have been laid to rest here. Actually it is no longer an abbey. Since 1560 it has been directly responsible to the sovereign as a 'Royal Peculiar'. With those connections Oliver Cromwell was buried here, only to be disinterred three years later and hanged from a gibbet at Tyburn. Geoffrey Chaucer was buried here, starting the burial or commemoration of poets and musicians, even admirals, scientists and politicians. A special place is reserved for the Unknown Warrior who rests here, representing the many unidentified dead from European battlefields.

Right: The grime of centuries has been cleaned off such iconic buildings as Westminster Abbey since this picture was taken.

St Margaret's, the parish church of the House of Commons, is to the left and Big Ben is in the background. Actually Big Ben is the great bell within the clock tower at the north end of the Palace of Westminster, not the tower. The tower's official title nowadays is the Elizabeth Tower.

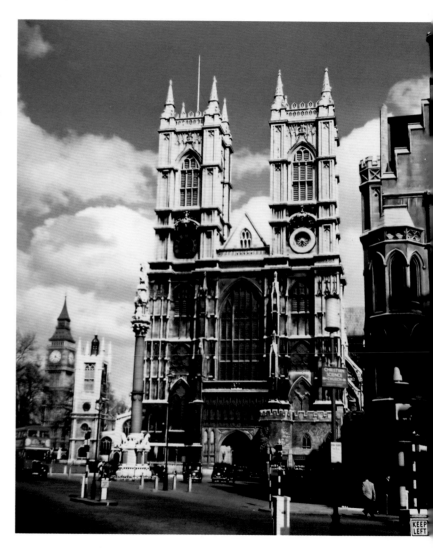

Berkeley Square

I never heard a nightingale sing in Berkeley Square, as Cole Porter's haunting song would have us believe – a pigeon had to stand in for the elusive bird. The old plane trees are surrounded by some of London's most sought-after real estate. Laid out in 1730, the well-favoured green was and perhaps is, a very genteel and respectable place, with Rolls Royce's large car showroom, *Reader's Digest*, a nightspot and a large florists flanking it. Two Prime Ministers at one time resided here, and it is said that in one of the Georgian houses a ghostly apparition is likely to scare you to death.

At one time I had reason to call at a client in one of the side roads just off the square. In a narrow, old-fashioned building a darkly angled staircase climbed the several floors to my clients that I remember for reasons other than the song of a nightingale. There were footsteps and whispers and poorly suppressed giggles ahead as I ascended the stairs on one occasion.

A rabble of younger fellows, messenger boys most likely, dispersed as I approached. One sunlit sash window, the lower half of which was raised and opened quite low on

the landing, thus allowing for the circulation of air on the warm summer's day? Or so I thought. A sideways glance soon revealed the source of attention of the flighty fellows. The open window allowed access onto the flat roof of a lower building extension set at an angle and there, a few floors above the bustle of the busy narrow street, reclined the source of attention of the whisperers on a casually spread towel – a thoroughly modern maiden, quite nude except for sunglasses, totally unconcerned by the attention she was inviting, allowing the sunshine access to every pore of her youngish body while, apparently, totally concentrating on improving her mind by perusing a paperback book ...

Right: Wellington's Triumphal Arch, Hyde Park Corner

The *Angel of Peace* rides in on a four-horse chariot of war, elevated on an arch in honour of Wellington's victory over Napoleon. The arch is hollow and can be accessed by the public today. Until 1992 it accommodated a small police station.

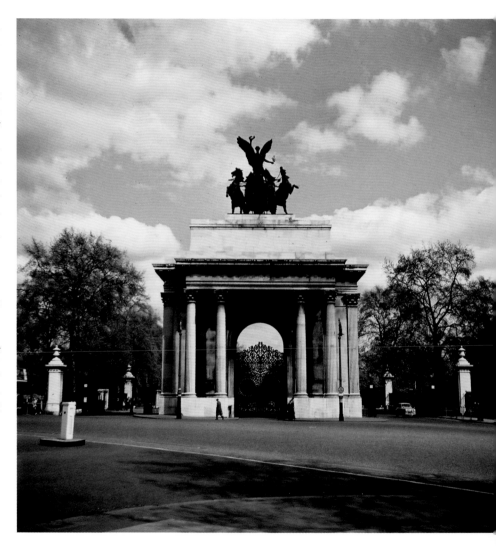

Pigeons and Lions of Trafalgar Square

The area had been cleared in the first half of the nineteenth century when a Corinthian column of some 170 feet in height was erected, guarded by four monumental bronze lions and topped by a statue of Horatio Nelson, the victor who commanded the British fleet at the Battle of Trafalgar.

Policemen, or 'bobbies', had a quaint, almost gentle reputation, yet they aborted my earliest attempts at finding a more unusual angle for my photos. My first encounter was at Trafalgar Square, where I attempted to photograph the scene from an elevated position, having followed the cue of others and climbed up on one of the lions with my camera. Of course, others wisely disappeared when a twin pair of bobbies arrived at the base of the pedestal, demanding my immediate descent. I obliged, but I must have registered my displeasure at such treatment, for one of the pair tried to install a sense of reason into the occasion.

'Where do you come from?'

I admitted my origins.

'Ah, well, you will have monuments in Germany?' He was trying to think of an example.

His colleague helped out: 'The Brandenburgh Gate…'

'Yes, if I climbed all over the Brandenburgh Gate, your Police would soon have something to say about that.' He felt vindicated. The Brandenburg Gate in Berlin was the flash point between east and west, between Russian occupation and the Allied sectors. Surrounded by barbed wire, which later became a concrete wall, an English bobby climbing it would have created nothing less than a Cold War incident. He might even have been shot down, I mused, counting myself lucky.

On a later occasion I passed through central London on my way from Wales to Essex. Somehow I ended up travelling east between Trafalgar Square and the National Gallery on an evening when Italy had won a major game of football. Singing, dancing, scarf-waving compatriots of that august country thought nothing of holding up the traffic to share their delight and dancing on cars in their euphoria. Hilarious and admirable perhaps to the celebrants, but not to a tired motorist who'd rather be on his way. Since 2003 the road running along the north side of the square has been pedestrianised and closed to traffic.

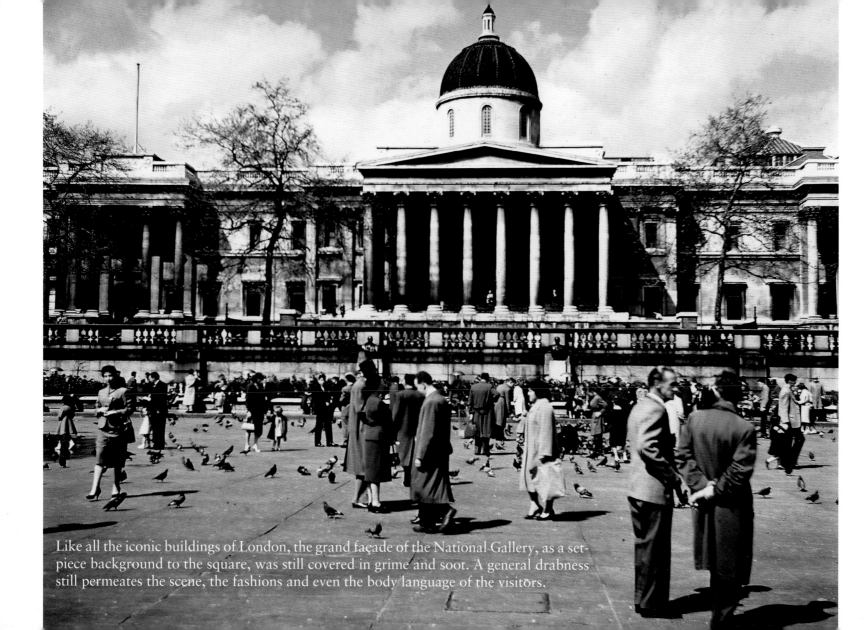

Like all the iconic buildings of London, the grand façade of the National Gallery, as a set-piece background to the square, was still covered in grime and soot. A general drabness still permeates the scene, the fashions and even the body language of the visitors.

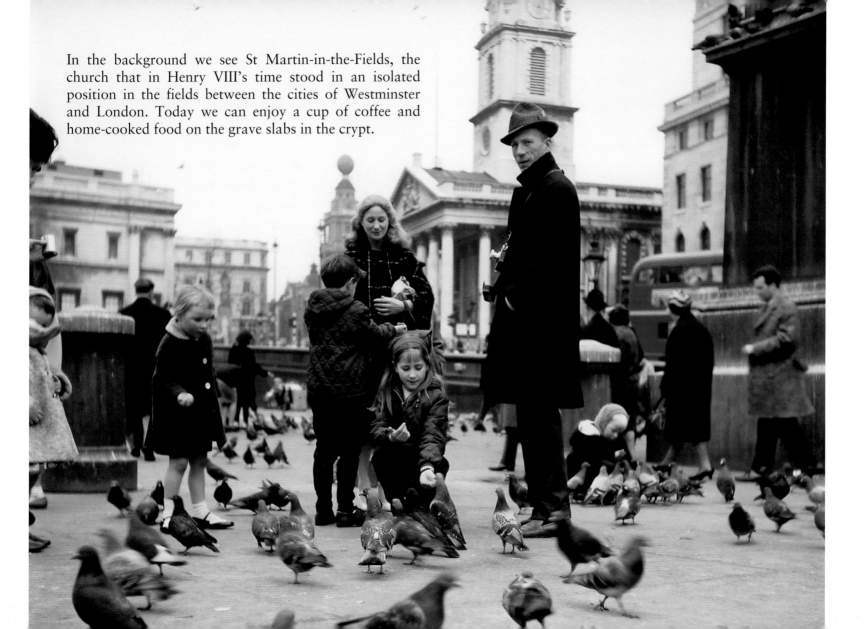

In the background we see St Martin-in-the-Fields, the church that in Henry VIII's time stood in an isolated position in the fields between the cities of Westminster and London. Today we can enjoy a cup of coffee and home-cooked food on the grave slabs in the crypt.

Trooping the Colour, the Queen's Birthday Parade

It is a custom that dates back to the seventeenth century and King Charles II, when troops needed to recognise their colours or flags in battle. Later it became the custom to mark the sovereign's 'official' birthday, a state affair ignoring the actual date. Until 1986, on some thirty-six occasions, the Queen rode side-saddle, wearing the uniform of whatever regiment's colour was being trooped. It's an annual spectacle of pageantry, come rain or come shine.

The spectacle of the horses and the uniforms and the music, policemen strung out the length of the Mall along both sides, keeping collective eyes on the crowd. The crowd, thronging along the sidewalks several people deep, eager not to miss the spectacle. I had to raise my camera over the heads in front of me to try to catch the subjects. In medium format cameras the viewing mirror shows the image moving in the opposite direction, opposed to reality. Upside-down that was not an easy experience and most of my pictures suffered from camera shake or soft focus. To make matters worse, having secured a better position for the return ride, just at the crucial moment the camera ran out of film.

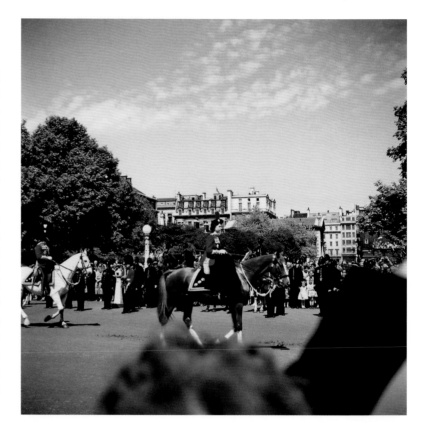

Above and opposite: A young Queen Elizabeth II riding side-saddle along the Mall. Prince Phillip, also resplendent in his uniform, with a huge bearskin hat, rides beside and slightly behind her.

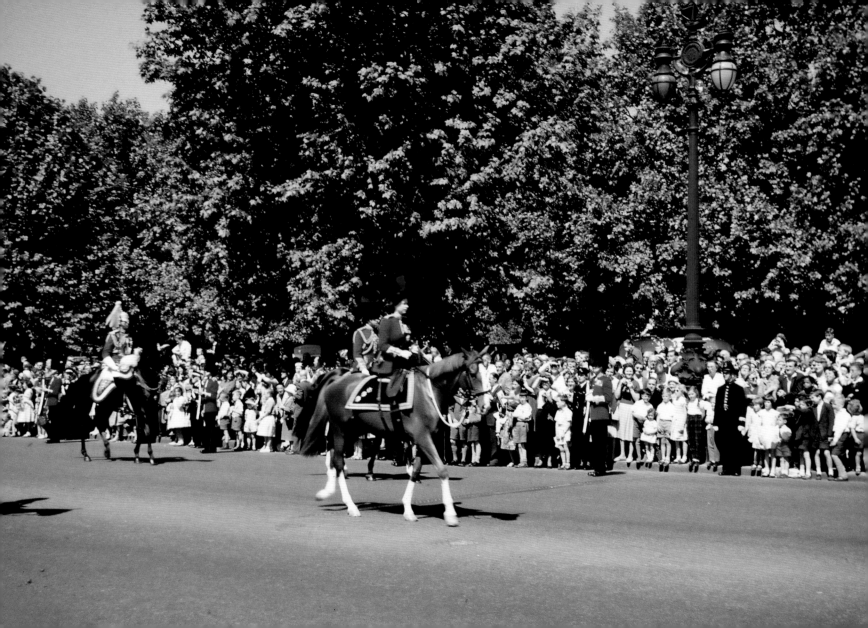

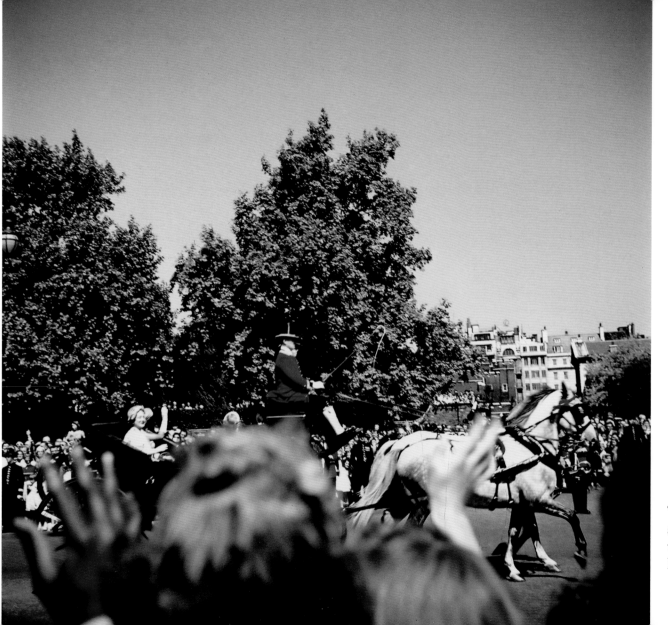

The queen mother
and other worthies
waving from open
Landau carriages.

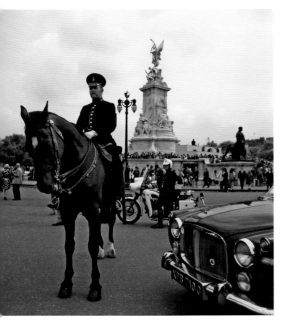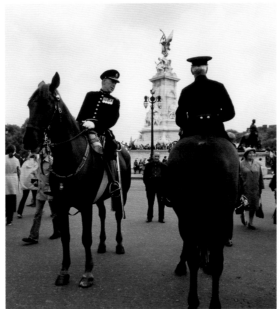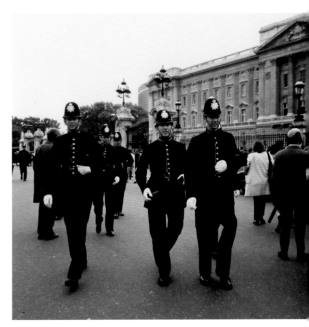

Victoria Monument and Buckingham Palace after the event. I never saw so many happy policemen.

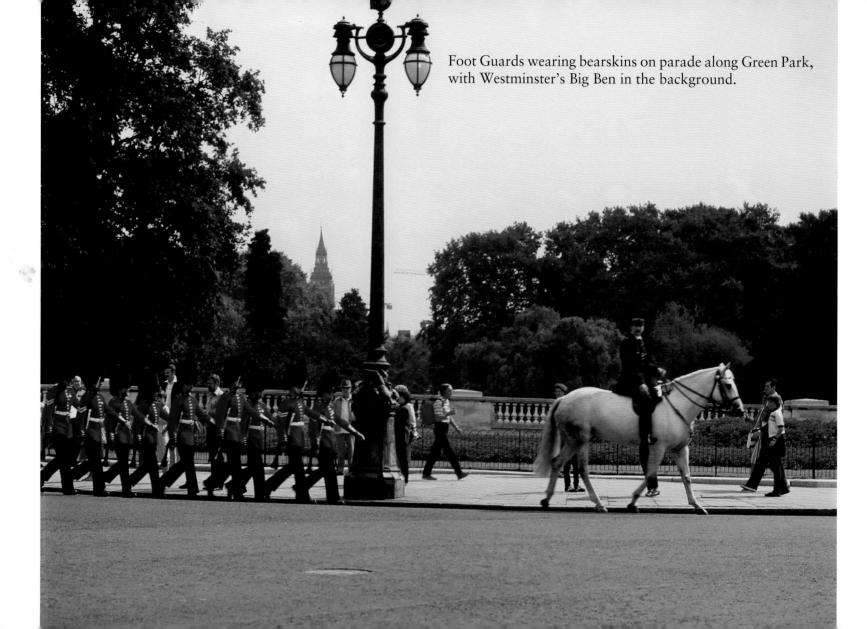

Foot Guards wearing bearskins on parade along Green Park, with Westminster's Big Ben in the background.

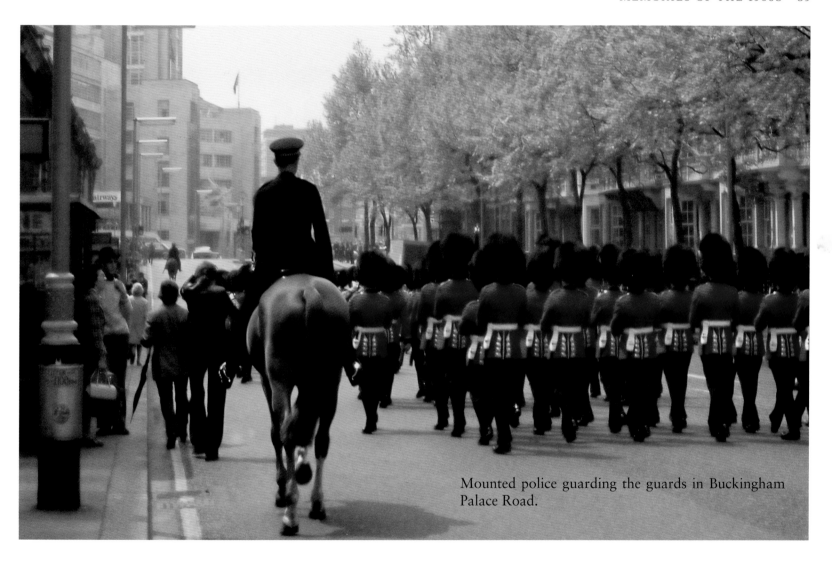

Mounted police guarding the guards in Buckingham Palace Road.

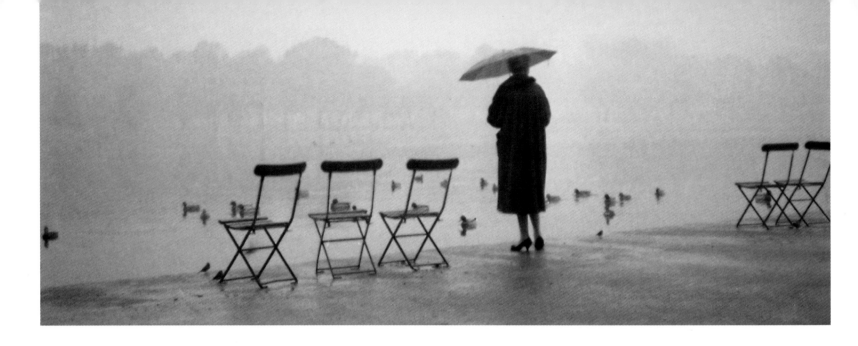

The Serpentine Lido in Hyde Park

The year I first arrived in London, 1956, was the year the Clean Air Act was introduced. The Great Smog had passed in 1952 when a thick, greasy, grimy fog claimed the lives of 12,000 people in four days. It had been a pea-souper, with another 8,000 dying from inhaling effects in the months following.

'You with your asthma won't stand a chance,' I had been warned. Though the worst was past, fog can still descend on the town, as it can appear anywhere else, though while it may play havoc with traffic, it has never again been as deadly. On the contrary, I have always found it rather otherworldly and exciting, not knowing what's around the next corner.

'A foggy day in London Town,' crooned Frank Sinatra in a Gershwin song in 1960, as have many of the greatest singers before and since:

> And suddenly I saw you there
> And in foggy London Town
> The sun was shining everywhere.

If you're young and in love, London in a mist can be unhealthy, but also the most romantic of places.

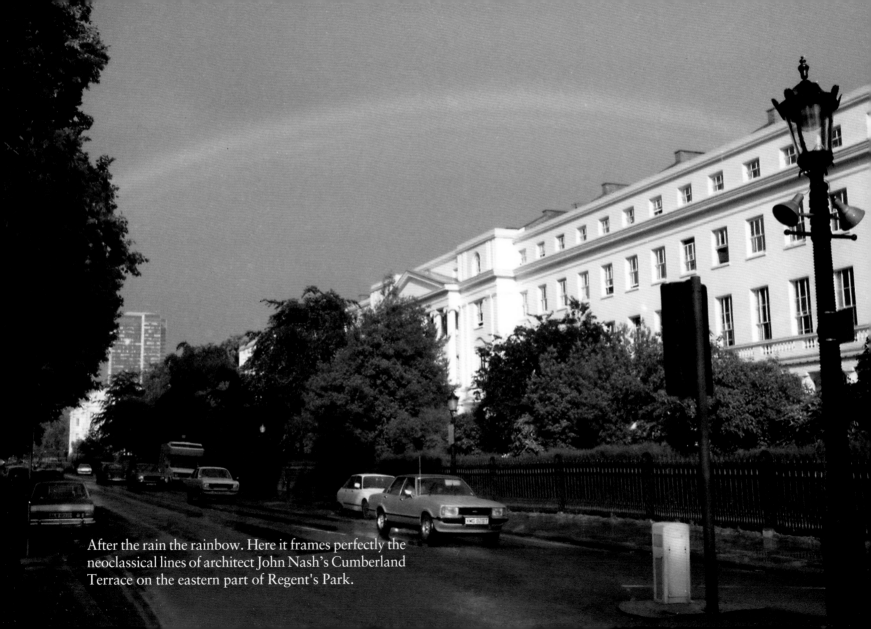

After the rain the rainbow. Here it frames perfectly the neoclassical lines of architect John Nash's Cumberland Terrace on the eastern part of Regent's Park.

Above right: The Largest of the Capital's Eight Royal Parks

Richmond Park is a National Nature Reserve. The herds of red and fallow deer have been here since Charles I enclosed it, but its origins go back to before the fifteenth century. The Old Deer Park was a Royal demesne when the Saxon kings had their palace here. People mingle with the relaxed but wild grazing deer. In the distance the late 1950s-built, high-rise flats of the Alton estate on Roehampton's border with Richmond Park bring us back to reality.

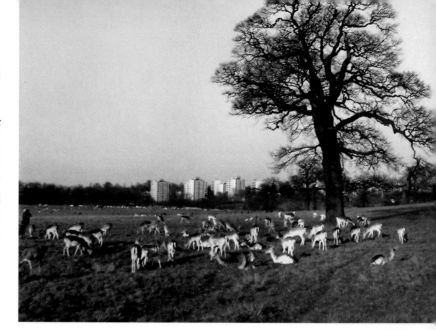

Below right: Hampton Court Bridge

An impromptu musical interlude on the banks of the Thames by the fourth bridge to cross near Hampton Court Palace. Passers-by stop to listen. This bridge was built in the early 1930s. The first crossing in the 1750s was fashioned of wood and based on the then popular design of the willow pattern. The centre supports of that construction had pagoda-style roofs and the seven spans were individually arched, just as on the China porcelain design.

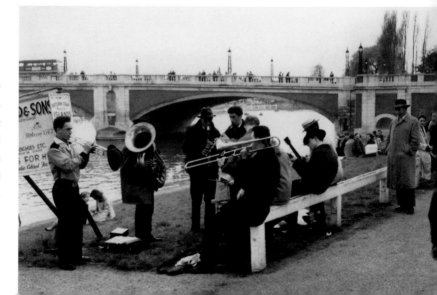

Right: Photographic Experiments

Encouraged by such famous and influential names as Magnum member Ernst Haas, I, too, tried to catch movement in still photographs. Pressing the camera for steadiness during long exposures against solid objects like walls or street furniture, it would be possible to take night images even without a cumbersome tripod. Strangers passing a brightly lit shop window during the exposure recorded their ghostly presence in passing.

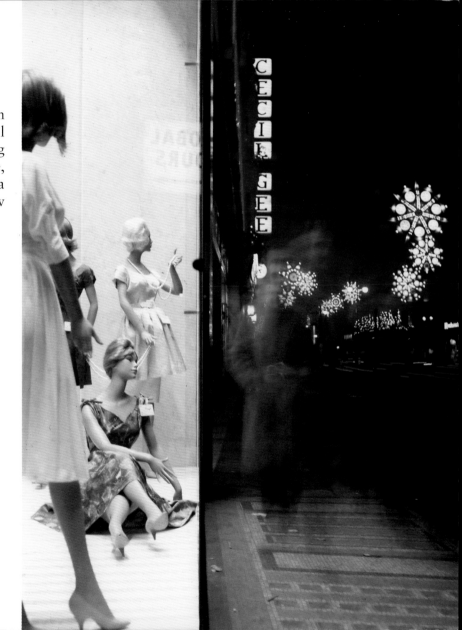

Above: Searching for the unconscious face of a city by recording graffiti or as here, the residue of past advertising. Do you remember the Milk Marketing Board's sixties' slogan, 'drinka pinta milka day', when every schoolchild was allowed a third of a bottle of milk? Margaret Thatcher put a stop to that.

Right: With all the experiments in fashion at the time I thought it great fun to photograph a young German-born artist as 'typically English'.

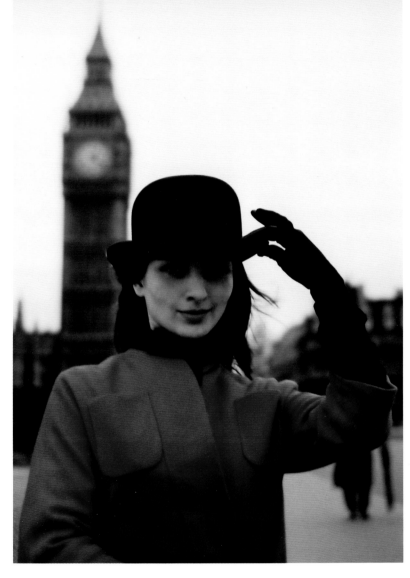

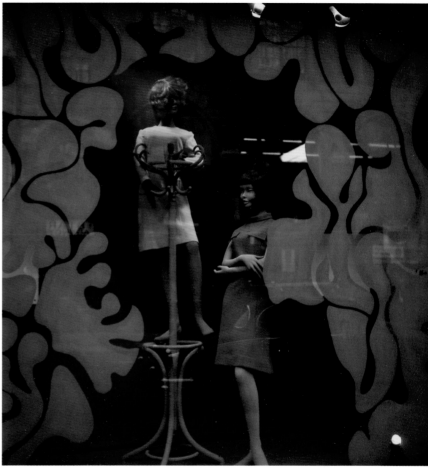

Above left and right: The West End became more colourful. Shop owners as well as fashion designers began to experiment to interest young shoppers. Even colourful old uniforms were adapted for street wear.

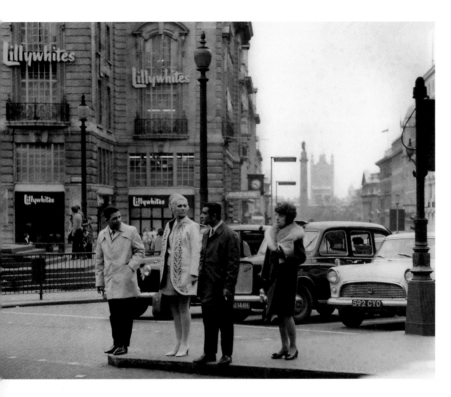 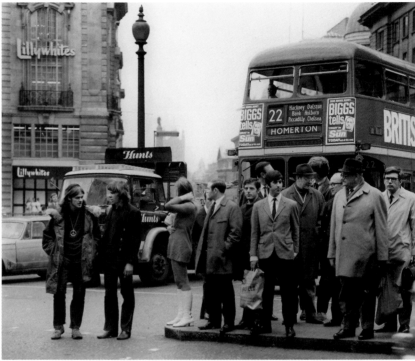

Above left: With traditional London black-cab taxis as part of the easily recognisable background, the statuesque young lady shows her pride and defiance, while still being the centre of attention.

Above right: Several signs of the times are there in the photo: the ban-the-bomb medallion, the 'Biggs tells the Sun' reference to the Great Train Robbery, men dressed for the office with hats and briefcases … The girl had spotted me and turned away, but she stayed for some little while all the same.

A Miniskirt on Piccadilly

Various fashionistas have been accorded the accolade of creating the miniskirt, notably Mary Quant in her boutique in the Kings Road, Chelsea, and André Courrèges and John Bates, all around the same time, but perhaps it was simply part of the new freedom of the times, more youthful, more comfortable and more daring. It was so radical by the mid-sixties even I woke up to the phenomenon when it was the talk of the studios and I was determined to catch that new style on film. I positioned myself at a site with a staid but recognisable background, here in Piccadilly, looking down to iconic Whitehall. There I waited for a young lady in miniskirt or minidress and high white boots.

Right: King of the Buskers

Don Partridge was a street busker in the old tradition in spite of his age, performing to the accompaniment of his own guitar, with the busker's traditional drum slung on his back, a pair of small cymbals strapped between his knees and a neck-mounted kazoo – a one-man band.

On the face of it an unlikely candidate for chart success, but he was 'discovered' and his first hit was 'Rosie', which he'd written himself and which reached No. 4 in the pop charts in 1968. The follow-up, 'Blue Eyes', peaked at No. 3. Eventually fickle fame avoided him and he went back to busking, here among the garbage bags in a small market in Little Argyll Street, with the London Palladium and Liberty's store in the background.

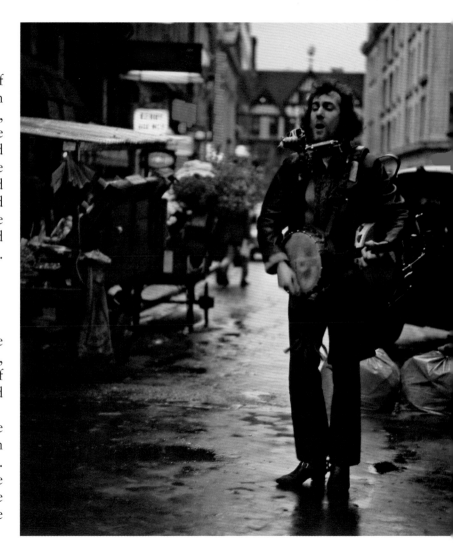

When I first arrived in London, there were all kinds of buskers and street entertainers, playing and performing along the streets, on Underground platforms, at queues – wherever people congregated – and it was equally certain that they would be arrested by police, fined or just moved on. One of the best-known groups was a skinny and threadbare couple who dressed like 'Egyptians', played what was perceived as Egyptian music and put down sand on which to do their desert sand shuffle.

Following my first night in London I was woken up by the harmonising sound of four buskers swinging single file through the streets of Paddington, stopping now and then to collect coins thrown from sash windows above them. Vigilance was essential; the old-style pennies were so large they could be dangerous missiles.

Regent's Park Zoo

Chi Chi the giant panda. One of the most boring and also perhaps the most endearing creatures in creation must surely be the panda. There seems to be little interest in the continuation of the species, so much so that the panda has become the symbol of the World Wildlife Fund. All Pandas seem to be interested in is eating bamboo in their native China, so science has been called on to help with their survival.

Born and caught in 1957, Chi Chi came to London via Beijing Zoo, Moscow Zoo, Tierpark Berlin, Frankfurt Zoo and Copenhagen Zoo, arriving in September 1958. She had been sold to an American zoo, but diplomatic problems meant that

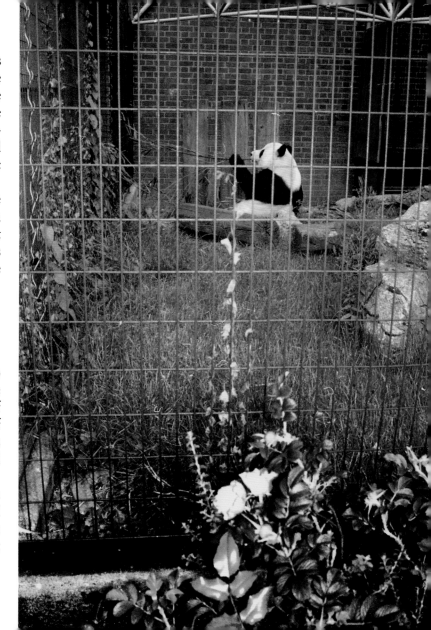

The rhino in my photograph grumpily turned its back on such fame as my photography might bring.

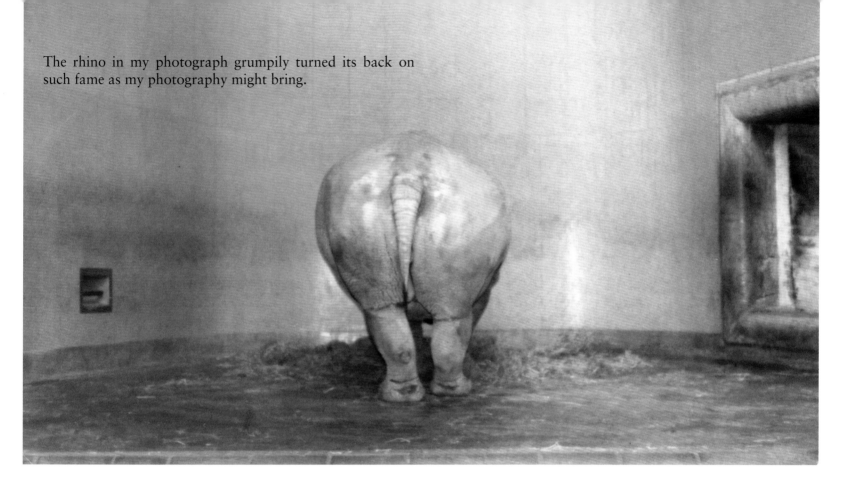

the USA did not deal with communist China at the time and Chi Chi was refused entry. The Zoological Society of London bought her for £12,000. She soon became the star attraction and when she died in July 1972 she was mourned by the nation.

Attempts to mate her with Moscow Zoo's An An had proved unsuccessful, yet such was her fame, you can still visit Chi Chi, albeit as a stuffed exhibit in a glass case at the Natural History Museum.

2

MEMORIES OF THE 1970S

London was beginning to be colourful. Decimal currency was introduced and I could no longer charge for my work in guineas. Britain joined the European Union. The Irish Republican Army bombed Parliament and Margaret Thatcher became leader of the Conservative Party.

New thinking and creativity flourished. In 1977 shops especially blossomed with the celebration of the Queen's Silver Jubilee. Red Rum won the Grand National for the third time. The time of the sombre trench coat and the pinafore was past, and while hair grew longer and wilder, hats disappeared to be replaced by fez and turban. Prime Minister Harold Wilson favoured the duffel coat and Parliament abolished capital punishment.

From the Romans who built a wall around it and the Normans who built the Tower, London has always attracted newcomers, sometimes even welcomed them. It's been a safe haven from persecution for immigrants for centuries and when push came to shove, many of their descendants helped to defend the country with their lives. They brought their customs with them, too. London's Chinese community established themselves in an area about Gerrard Street and their colourful New Year celebrations began to liven up Februarys.

The world was coming to London – travel on London's Underground and you'll meet the world; from Indian ladies in colourful saris to dapper Scots in kilt and sporran.

You would meet the fashion-conscious in combinations of new mixed with the traditional pinstripes and bowler hat of the city worker, heavies in chains and bovver boots and sneaks on platforms – some, ardently preaching, would save your soul and some would prefer your money – not forgetting the voluminous down-and-out travelling with all his or her possessions, assuring their personal space by exuding their own unique aroma.

You might marvel at a young or not-so-young lady in a miniskirt so short it was known as a 'pelmet', tottering along on bone-breaking stilettos, wearing a gauze see-through blouse, while her partner, dapper in traditional pinstripes and bowler hat, carried the baby.

Bell-bottoms made from denim, bright cotton and satin polyester were back with a vengeance, so much so that they still define the colourful and outlandish style of the decade.

Fashions became important individual statements of his or her outlook and aspirations. I, on the other hand, never seem to have been 'with it'.

While in Switzerland in 1971 women at last were allowed to vote, here in the last year of the decade Margaret Thatcher became Prime Minister.

Freedom of Speech on Tyburn Hill

Speakers' Corner in the north-east corner of Hyde Park represented the kind of freedom people in repressed countries could only dream of. I had been warned and there were dissenting voices: 'Don't you believe it,' someone commented, 'there are ears listening to everything that's said …' To me it was all-fascinating anyway. I did not understand much of what was said, nor did I stop to listen, being more occupied with a visual recording of the notion.

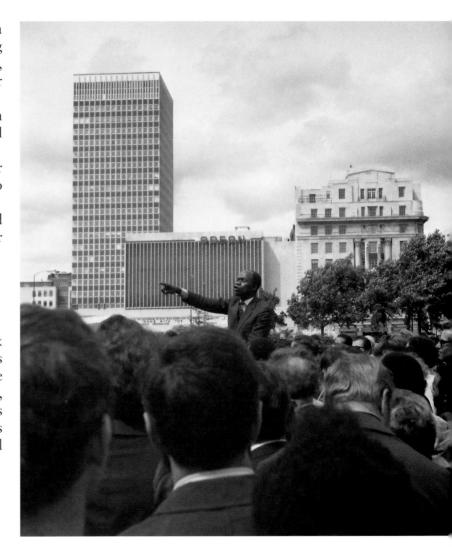

If there was surveillance, I did not notice, but the fact that people promoted all kinds of sometimes surreal and sometimes controversial notions, and that there were others who would listen to them or heckle, struck me as exciting and noteworthy. Idiosyncratic perhaps, but very 'English'.

The fact that in less humane times it had been the site of the Tyburn gallows and public executions did not occur to me then, nor was I aware that Speakers' Corner had also been frequented by the likes of Karl Marx, Vladimir Lenin, George Orwell, Kwame Nkrumah, William Morris ...

Visitors to Parliament Square

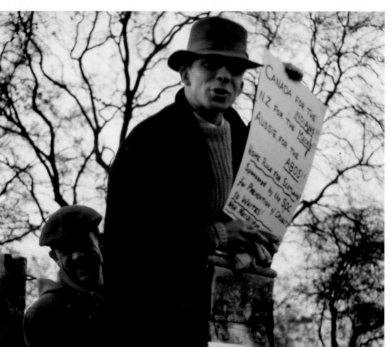

Studded with statues of statesmen of various ages, Parliament Square is a large traffic island, and until recent legislation was the recurring venue for democratic protest. About it to the east we find legislature in the Mother of Parliaments; to the north on Whitehall executive offices; to the west the judiciary in the Supreme Court; to the south St Margaret of Antioch's church with Westminster Abbey behind it. Together with Westminster Abbey and Westminster Palace, St Margaret's church is part of a World Heritage Site.

Until Henry VIII's Dissolution of the Monasteries in the sixteenth century the abbey was St Peter's Benedictine monastery. In order not to be disturbed during their devotions the monks built a smaller place of worship for local people next to it, now the parish church of the House of Commons.

Above: In the midst of traffic, a place to rest and show off the new fashionable hats. Abraham Lincoln in front of the Middlesex Guildhall looks on, still ignoring the chair the sculptor provided behind him.

Right: It would seem that pigeons come in many sizes in this picture. Behind St Margaret's we just see the roof of the abbey.

A Statue to Private Enterprise

A view down Whitehall from the southern edge of Trafalgar Square. Foreground left a statue of King Charles I, mounted and staring down Whitehall to the Houses of Parliament that caused him to lose his head following the bitter Civil War.

Puritans under Cromwell sold the wicked king's statue to a metal dealer called Rivett with the understanding that it would be broken up. Mr Rivett duly made his fortune selling bits, purportedly of the statue, as souvenirs. On the restoration to the throne of the king's son Charles II, miraculously the statue re-emerged from Mr Rivett's cellar undamaged and was duly sold back at another goodly profit.

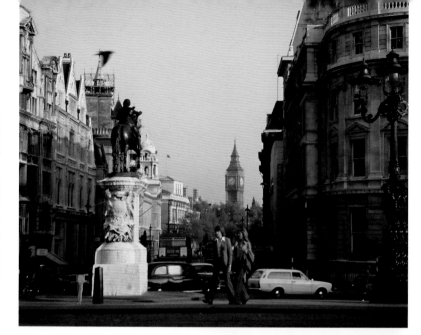

Bedford Row and Sandland Street, WC1

The area hasn't changed much in the years since that picture was taken. It's still the domain of law firms, barristers and solicitors, with its closeness to Lincoln's Inn Fields and the Inns of Court. The old water pump and former gaslight are still there and the Robinia trees still add colour between the Edwardian buildings on what once was part of the Duke of Bedford's Estate. Even the coats of arms of St Andrew and St George are still there on the non-functioning 1840s pump, but the young lady now has a daughter of a similar age to hers in around 1979.

A Foggy Day in Gracechurch Street

London in mist was no longer the dangerously unhealthy place it had been when depressing fog, traffic fumes and industrial processes mixed to create a deadly combination of killers. London especially used to have a spooky reputation abroad, fuelled by cheaply published romances and stories of Jack the Ripper and Sherlock Holmes, of gaslight glistening on damp cobblestones and cloaked strangers lurking in dark alleyways. I have always found the opposite to be the truth: when mist invades the traffic slows and the frantic activities of a great city calm down a little. Now traffic fumes make it unhealthy.

Below: A man carries traffic cones in a leafy Manchester Square.

Right: Here in Gracechurch Street we are looking south to the Monument to the Great Fire of London.

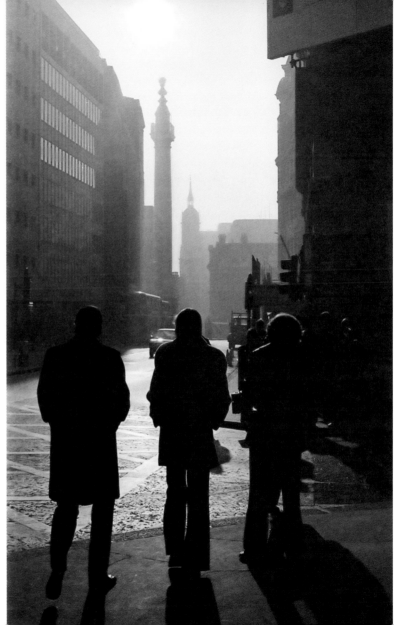

Fenchurch via Lombard Street to Bank

Crossing into the shady granite and concrete canyon of Lombard Street, one was always reminded of its remarkable past. A rare sense of history had preserved many of the signs of past commerce that hovered like inn signs above our heads, commemorating men and companies of pioneers of banking.

So narrow is the street and such was the echo of the clatter of horses and wheels in past times that the cobbles underfoot used to be made of rubber.

A blue plaque recalled the original Lloyd's Coffee House that was difficult to imagine among the bare granite walls of the present. St Mary Woolnoth church has survived in the hub of commercialism at the confluence of Lombard Street and King William Street, its approach reduced to a minimum and secured by a high and sturdy wrought-iron enclosure. Swirls of the ornate fencing used to suit newsvendors as handy storage racks for their surplus evening newspapers.

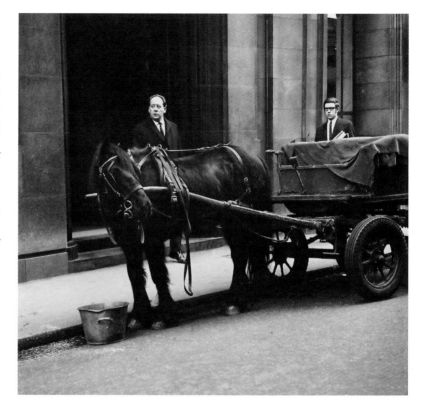

A horse in the City was a rare sight even then, as here in Lombard Street. Did Harold Steptoe leave his rag and bone carthorse Hercules for a bit of business at such an upmarket City establishment? (The TV sitcom *Steptoe and Son* had a second run in the early seventies.)

Right: A lady once pronounced proudly to me that Barclays needed to acquire just one more of the four-corner buildings on the crossing of Fenchurch Street and Gracechurch Street for it to become 'Barclays Corner'. It underlines the constantly changing scenes of London's streets and its skyline. Huge buildings are seemingly forever being erected and pulled down in this mecca of money. One large edifice on the corner of Lombard and Gracechurch Streets is now in its third reincarnation in my lifetime.

Below: Missing in the main picture is the ancient sign of the grasshopper at No. 68. It dates back to 1563 and Queen Elizabeth I's financial agent, Sir Thomas Gresham (d. 1579), who played an important part in the development of English banking – a wool merchant who added a goldsmith's business to his interests. Gresham moved here and established the sign of the Golden Grasshopper.

He persuaded the Crown to cease borrowing from continental lenders and look to the London moneylenders instead. Realising the potential contribution of the Lombard Street merchants to the national wealth he established the first Royal Exchange, which was opened by Queen Elizabeth I in 1571.

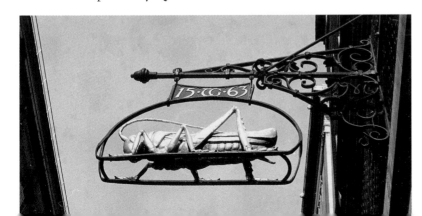

Opposite: Yellow Moon over Tower Hill

The White Tower in the centre was built to terrify prospective invaders and Londoners alike after the Norman Conquest in 1078. Royal palace and fortress, home of ravens and beefeaters, it spans centuries of mystery, murder and malevolence. It's been a place of execution and a prison: Anne Boleyn lost her head to the sword of a French executioner on a scaffold erected on the north side of the White Tower. The last criminals to be secured here were the Kray twins in 1952.

Right: Beefeaters as Guides

Guards at the Tower of London are Yeoman Warders, better known as Beefeaters. An unusual description, possibly reaching back to the time when part of their wages was paid in beef, or it may refer to the French 'buffetier', the French king's royal guards who protected his food. Today they guard the Crown jewels, though their main occupation is as tour guides and thus they are their own tourist attraction.

'Don't tell me what it's for, I'm not allowed to know that,' explained the stout warder when I tried to explain my interest.

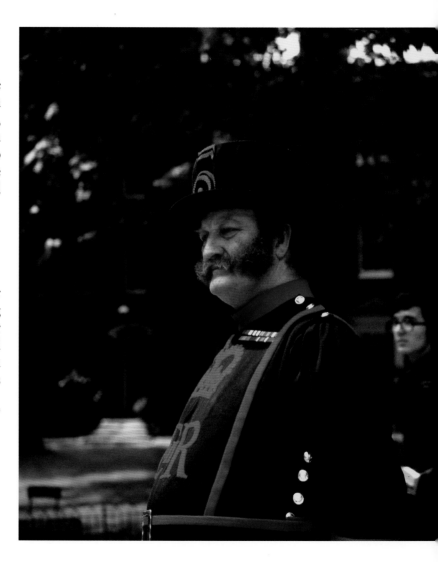

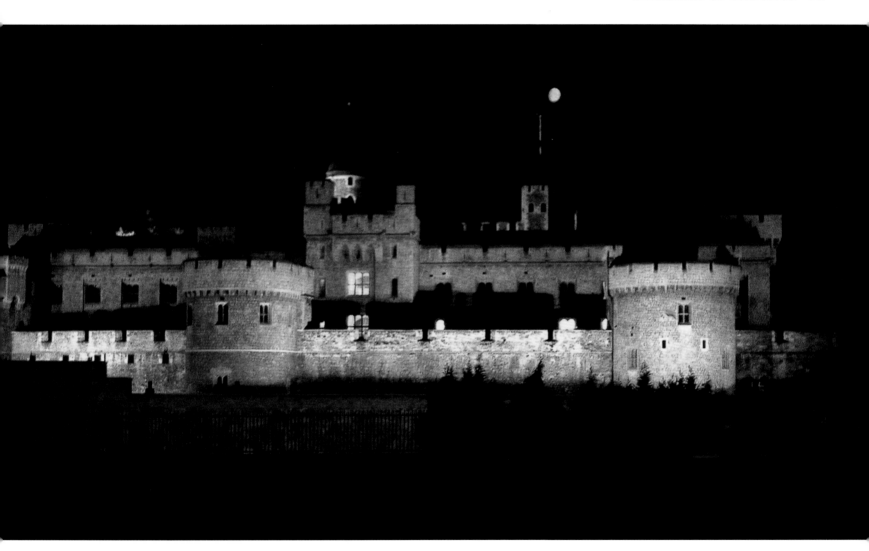

Fleet Street, the Home of Newsprint

Named after London's largest, now underground, river, the Fleet, it connects the City of commerce to the centre of politics in Westminster. In the Middle Ages bishops built their palaces here, though later it became known for taverns and coffee houses. Running from Ludgate Hill to the Strand, it was one of the busiest streets in London.

Ludgate Hill railway station was built in the late 1860s for the London, Chatham & Dover Railway, and the railway bridge that crossed Fleet Street was added in 1874. The line was closed again in 1923 but remarkably the bridge survived until 1990, obstructing the view up Ludgate Hill to St Paul's Cathedral. To the right of the bridge and between the dark wall and the red-brick striped building behind it lay a ruined plot, the last bombsite to be rebuilt after the war.

In Fleet Street, one of the survivors of the once prolific taverns is Ye Olde Cheshire Cheese. It was rebuilt soon after the Great Fire of London in 1666, having been established at the site in some form or other since 1538. In the thirteenth century its cellars were part of a Carmelite monastery. In its long history it has been among the favourite tippling houses of some rather famous literary figures including Charles Dickens, Sir Arthur Conan Doyle, Mark Twain, Alfred Tennyson and G. K. Chesterton. As member of the Typographical Society, some of our meetings were held in the vaulted cellars of the Grade II listed hostelry on Wine Office Court.

Fuelled by wine and the proud bond of the street to my typographical calling in that historical setting, youthful exuberance must have loosened my tongue and my usual reticence evaporated until in the gloomy atmosphere a sober voice challenged me with his astonishing knowledge: 'Aren't you from Westfalia?' An American professor of languages had placed me right into my home county. That cut me to the quick, as I had learnt my English in Wales and thought my utterances were adequately camouflaged. Needless to say, it was an instantly sobering experience.

Opposite above right: Reuters were the last major British news office to leave Fleet Street in 2005.

Opposite below left: Former offices of the *Daily Telegraph*, the *Daily Express* and the Reuters organisation are listed buildings now.

Opposite below right: St Bride's wedding-cake spire rises above Fleet Street, an icon of history in the City of London. Six previous churches have stood here. The church traces its history back to Celtic monks from Eire in the seventh century. A church here burnt down in the Great Fire of 1666; it was rebuilt by Sir Christopher Wren. In 1940 it fell victim to incendiary bombs that left it a roofless shell. It's the second tallest of all of Wren's churches after St Paul's Cathedral. Its connection to the newspaper industry dates back to 1500 when one Wynkin de Worde set up a printing press next door. Only in London was printing permitted by law until 1695.

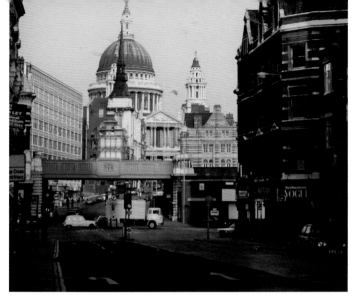

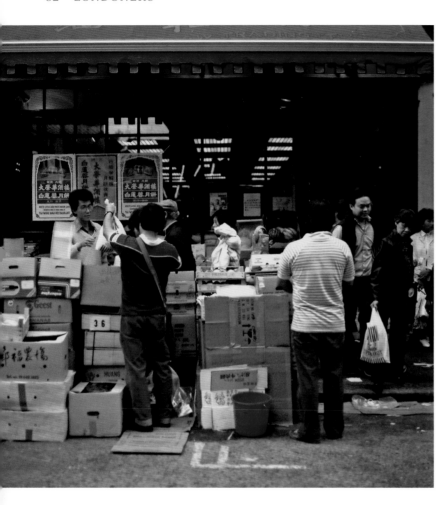

Chinese cuisine supplies spilled out on to the street.

Celebrating New Year in Chinatown

In the early 1970s London's Chinatown had grown sufficiently to put on their communal New Year celebrations with lion dances, food offerings to the ancestors, balloons and traditions (cabbage for prosperity and luck, ingot-shaped packages for wealth). Today the annual event has outgrown the area about Gerrard Street towards Trafalgar Square and London hosts the biggest Chinese New Year celebrations in the world outside of China.

For many years a Far Eastern travel agency was one of my most interesting clients with bilingual publications and colourful European destinations.

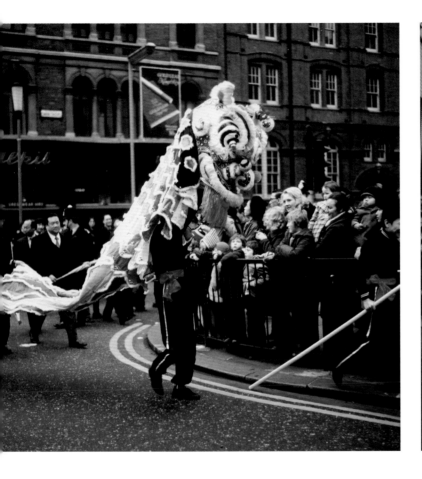

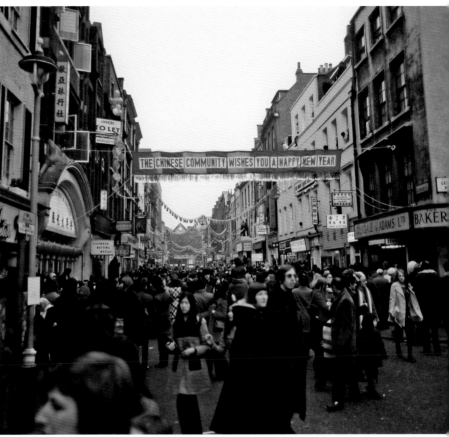

Opposite: The Tramp and the Missionaries

Sometimes, when the strains and stresses of life weigh heavily, we may wish for the seemingly easy and carefree life of the vagabond, the tramp or the bag lady. Owing no taxes, paying no landlords, sleeping under bridges or in derelict doorways … In a civilised society there should be no need for such an existence, but there is always the choice of the individual, who, for whatever reason, slips through the welfare net. They're not all beggars.

Right: Feeding the Feral Pigeons

Pigeons were famous in Trafalgar Square and people came to feed them, but they were becoming a dirty and unhealthy nuisance, no longer wanted in a health-conscious age. There had been an estimated 35,000 of them when the then-mayor Ken Livingston banned feeding the health hazard in 2003, and with the aid of a falconer and his trained Harris's hawk the new millennium has seen the square become practically pigeon free.

 Far bigger game once roamed the area some 40,000 years ago. In 1960 archaeologists digging on the south side of the square found remains of cave lion, rhinoceros, straight-tusked elephant and hippopotamus.

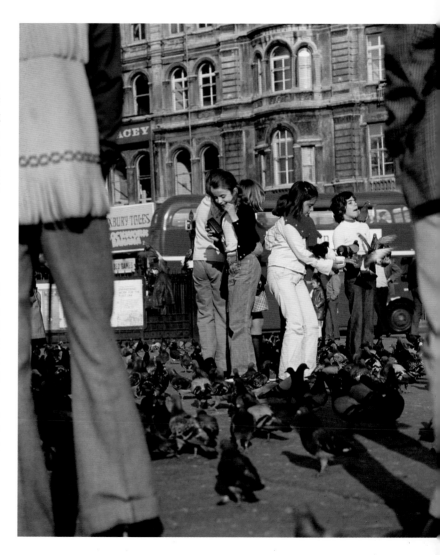

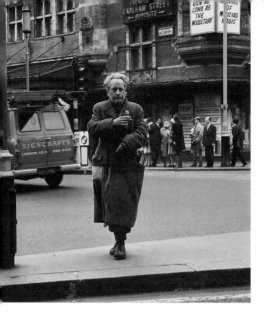 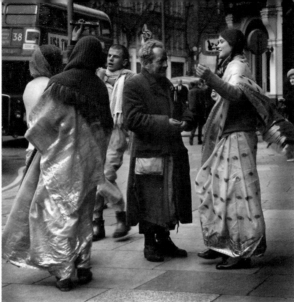 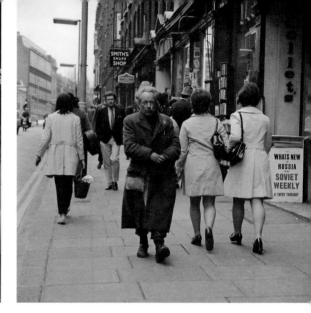

Above left: This gentleman of the road seemed content just to be – wandering the streets, clutching his bottle of elixir, even joining in the fun. Early last century, in the era of silent films, Charlie Chaplin made his fortune playing just such a character. There, but for the grace of God, go I.

Behind him, at the grubby corner of Shaftesbury Avenue and Charing Cross Road, the Palace Theatre posters promise an entertaining time with Danny la Rue (1970–71).

Above middle: Surrounded by the friendly chants of Hare Krishna devotees who could be heard along the pavements of the West End. The young men are shaven-headed, in long orange robes and sandals, beating drums. The women are in long, swirling, colourful saris, dancing, clapping hands and shaking tambourines in joyful worship of their deity. 'Hare Krishna. Hare Rama.' Again and again. Over and over.

Above right: Early in the 1970s a snuff shop was still advertising and *Soviet Weekly* offered to tell all that was new in Russia.

A Knees-Up with Flares and Platform Shoes

I was never a professional photographer, though when agency friends suggested an explorational shoot for ideas for British Airways (then BOAC) and tourism, I did not have to be asked twice. The brief was wide open; it was to shoot ideas around London that would attract tourists. London was my oyster – without a budget, of course. I found friendly and trendy young people who were prepared to go along with my suggestion for a knees-up right there in a for once remarkably pigeon-free Trafalgar Square.

At the Bank of England that same day I asked a passing lady to offer her bunch of flowers to a mounted policeman. The shoot? That went to a professional with professional models in white suits and a specially hired red London bus.

Lilac Time in the City

The City of London has its own liveried upholders of the law – the City of London Police. The officer on the dappled grey horse was all smiles. It was a brilliant day, sunny and hot, with the sun almost at its zenith. The horse was patient and compliant in the unnatural element, standing with dignified tolerance on the hard surface in front of the Royal Exchange and the Bank of England, shaking its noble head occasionally as if to prove it was not a statue, but allowing people to pet it, touch it and stroke the ridge of its nose. Young ladies struggling on platform shoes took a great tactile interest. Whenever anyone came too close or took too much of a liberty and forgot that this was a living, breathing being with the powerful iron-shod legs to enforce its own will had it wished to, the policeman would warn people in a friendly, no-nonsense way.

When a pretty lady happened to walk past carrying a large bouquet of lilacs, I saw my chance. I approached her with my quest of trying to get a lively shot for a British Airways tourism exercise. Would she perhaps offer the flowers up to the policeman in a friendly gesture? She responded to my accent – she was German or of German extraction, too. So I also asked the long arm of the law to accept, at least in a miming fashion, the lady's offered flowers.

My request was denied, however, in a very civil manner. This was a recruitment drive, and anyway, he was not allowed to accept gifts from the public, not even appearing to. It could be interpreted as bribery.

What, I asked, if the lady offered him a flower but he refused to accept it? Was there a law against that? No, that was fine. I got my friendly London picture, but the lady had moved too near the front end of the horse in the spirit of that happy day. Considering the horse had stood still for ages, the proud creature turned remarkably swiftly. Suddenly snapping sideways, it swallowed the fragrant floral tribute before one could even say, 'Catch that thief!'

I apologised and thanked the lady. Though her lilac bunch had depreciated a little, she did not seem to mind. Perhaps it was something of a welcome diversion for her, too. It's not every day that you feed a sprig of lilac to a horse in the City of London …

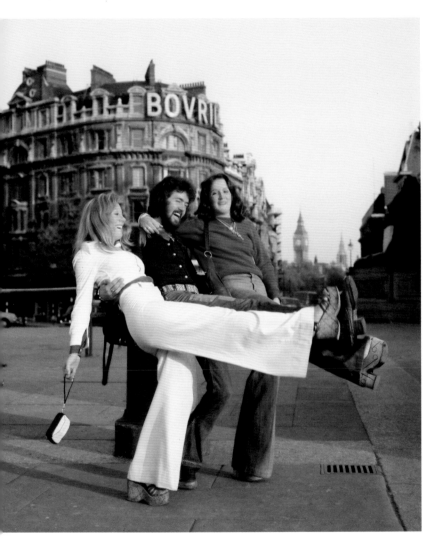

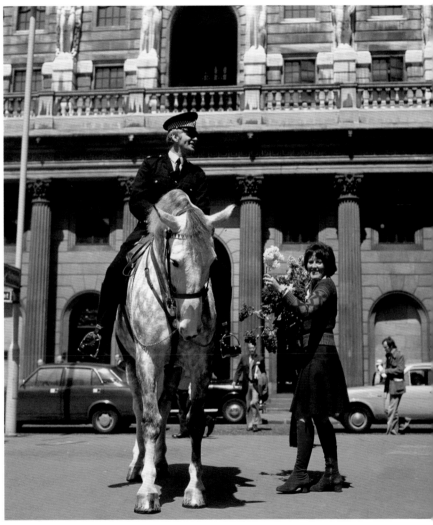

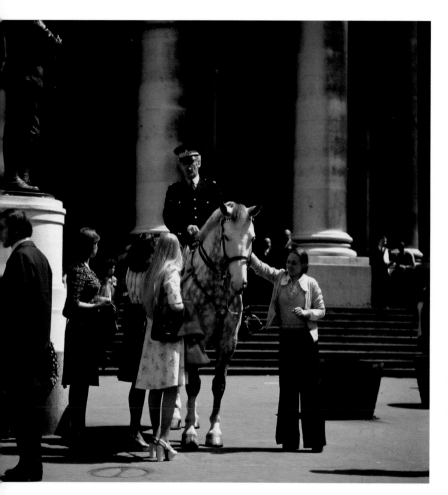

The patient dappled-grey horse was the centre of attention for the young City folk on their platform shoes.

Punks in Trafalgar Square

The Punk Rock movement had its zenith in the mid-seventies. They were certainly colourful, especially the Mohawks or Mohicans. The more outlandish the better. They were friendly and quite inoffensive, with plaid, leather and studs.

The Centre for Punk Culture

The most famous known hangout for punks was in the Kings Road. As a man with a camera I found a mixed bunch of devotees, and the sympathetic policeman added that extra bit of interest. One of their number followed me about, insisting I ought to pay for the privilege of taking their photographs. I remonstrated, suggesting that such payment would turn them into a commercial freak show of sorts. Still, he persisted. In the end I made an exception and parted with some loose change.

Assorted Mohawks and skinheads in their skin-tight leather pants, Dr. Martens, spiked dog collars and bracelets that seemed both dangerous and in a strange sense glamorous. Metal chains made some surprisingly unnecessary connections and safety pins became the must-have clothing accessories.

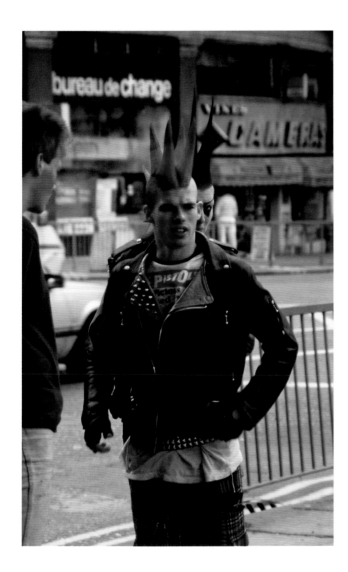

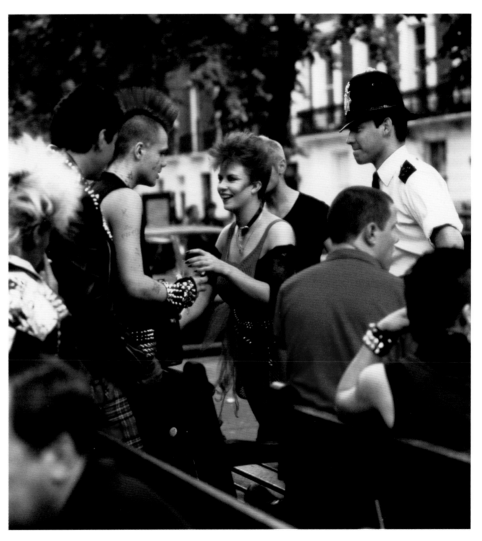

Easter Monday's Harness Horse Parade

With so many horses in London in Victorian times, their lot was often a dire one. To encourage the improvement of good welfare conditions and treatment of the capital's working horses, the Cart Horse Parade was founded in 1885 and the London Van Horse Parade followed in 1904. So popular were these turnouts that until 1914 entries were limited to 1,000. Eventually, and unavoidably perhaps, cars joined the parade and as horse numbers declined, in 1966 the two parades were amalgamated. Regents and Battersea Parks were the venues.

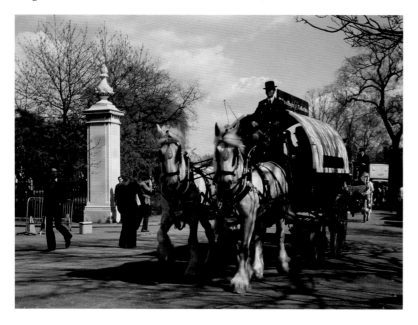

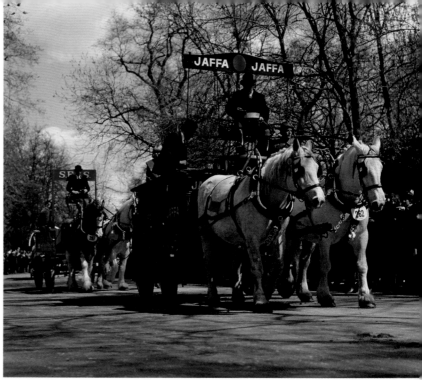

Above: Jaffa Oranges chose Percherons to attract the admirers.

Left: Whitbread's Gilbert and Sullivan at Regent's Park. Up on the driver's seat Ray Charlesworth, like all the human participants, is also traditionally dressed for the occasion. Immediately following is a single horse pulling a Mackeson dray.

The magnificent powerful and good-natured shires have always been among my favourites. The Parade still takes place on Easter Mondays, but it has moved out of London.

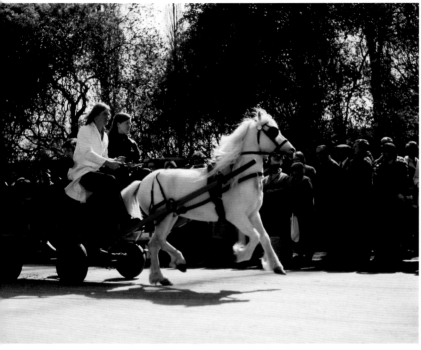

This show-off little carthorse seemed to relish its audience.

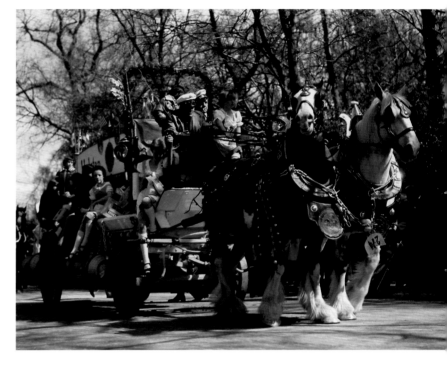

Holsten Pils were represented by a pair of lively and powerful shires.

Royal Oak Murals

Murals became widespread in the 1970s, an art form on a grand scale, often relating to the immediate environment. Sometimes they were ideologically charged, making wider social statements, as here beneath the Westway, just to the north of Royal Oak Tube station, on concrete piers of the motorway. David Binnington and Desmond Rochfort's murals were completed in 1976–7.

Below: Des Rochfort's homage to construction workers where monumental figures build and push forward and upward in a tribute to human labour.

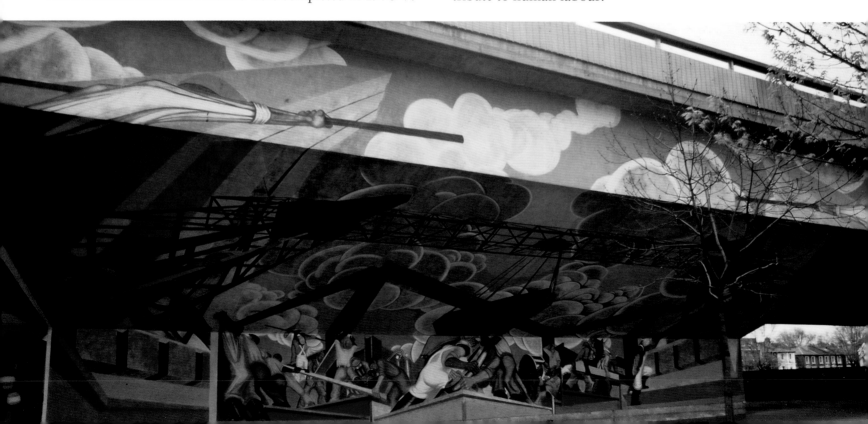

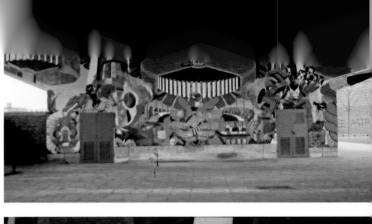

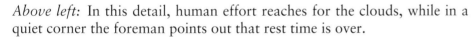

Above left: In this detail, human effort reaches for the clouds, while in a quiet corner the foreman points out that rest time is over.

Above right: The lettering spells 'SELL' to keep the cogs of industry turning. In David Binnington's *driving mechanisms of the Capitalist system*, the cogs turn relentlessly, driving the media attention. Even the athlete on her plinth is used as part of the media frenzy, the pressure to 'SELL'.

Right: An eagle-eyed Mr Big oversees the backbreaking work of his pinstriped minions, the graft and monotony, while unwelcome facts are being swept under the carpet.

The Romance of London

Ah, the romance of London. It may have been grimy, sometimes dark and depressing on rainy days, but when you're young and in love you're not aware of the crowds and London can feel like the only place to be.

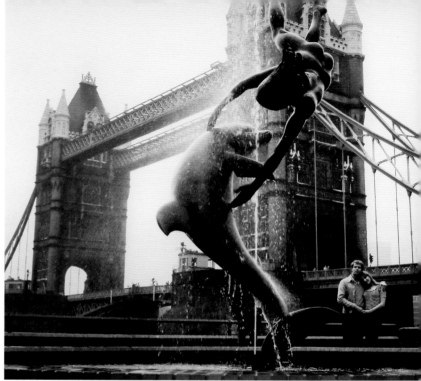

Above: Come rain or shine, London attracts its visitors. David Wynne's joyful 1973 statue *Girl with a Dolphin* near the Tower Hotel is a balancing act with the iconic Tower Bridge as a backdrop.

Left: A place for lovers. The view from the northern surrounds, backed by the neoclassical columns of the National Gallery to Trafalgar Square with Nelson on his lofty column, down to Big Ben and the Palace of Westminster. At the time the now-pedestrianised space between square and National Gallery was still a busy highway.

Framing the view down Whitehall, the Trafalgar Square dolphin and mermaid fountains designed by Sir Edwin Lutyens. Planned in the late 1930s, they were finished only after 1945. Lovers cuddle in the impressive setting.

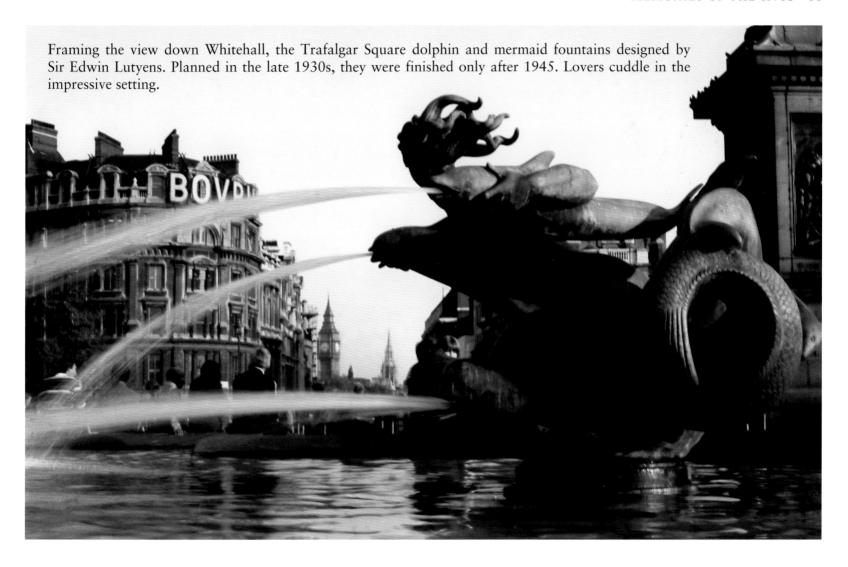

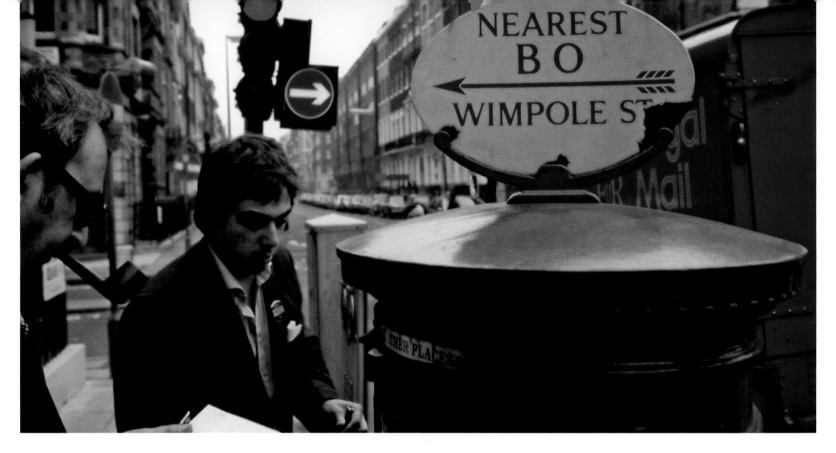

Cavendish Square

At the time an advertising campaign promoted cures for body odour, commonly referred to as 'BO'. Here, however, the arrow points in the direction of the nearest 'branch office' of the Royal Mail.

The view is down Harley Street, world renowned for its private surgeries. Overheard in an apothecary close to Harley Street when a private client complained not about the quality but the quantity of his prescription: 'I expected some medicine, not gallons of the stuff.'

Riders in Rotten Row

Hyde Park was created in 1536 as one of King Henry VIII's hunting grounds. Even before the Norman Conquest of 1066 it had belonged to the canons of Westminster Abbey. It was the hapless Charles I who opened it to the public in 1637.

The Easter Bonnet Parade in Hyde Park used to be a crowd puller in the 1950s. Since the late 1960s popular concerts have featured in the park, when bands like the Rolling Stones, Pink Floyd, Queen and Blur played to audiences of up to an estimated 500,000. The popular open space has also been a venue for protest demonstrations with masses of people taking part.

On 20 July 1982 the so-called Irish Republican Army took their bombing campaigns to both Hyde Park and Regent's Park, killing soldiers of the Household Cavalry and the Royal Green Jackets as well as their horses.

Rotten Row in Hyde Park, between Knightsbridge and the Serpentine, was 'the King's Private Road' when it was laid out by William III.

Take-Away Art on the Northern Edge of Hyde Park

Art on the railings along the Bayswater Road on Sunday mornings, where artists and craftsmen of all ages and nationalities, professionals and students, male and female, exhibit their original work – no prints allowed. I couldn't resist the chance and art from the railings still hangs on my wall.

Trending and Trading in Petticoat Lane

A real bit of traditional London, Petticoat Lane is, and has been for many years, a Sunday market for bargain-seekers of clothes and bric-a-brac, leatherwear, food, fruit and household goods etc. For a bit of haggling and browsing it's the biggest and the best. Actually it doesn't exist, not as Petticoat Lane anyway, as such a mention of an undergarment was anathema to Victorian sensibilities. The street's name was changed to Middlesex Street in somewhere between 1830 and 1846, though how the 'sex' part of the new moniker can be explained remains an enigma. Waves of immigrants have rejuvenated the market over the years, from Huguenots in the late seventeenth century and Jews in the late nineteenth century to Indians and Asians in the 1970s. Businessman Alan Sugar started here as a stallholder, and if it's good enough for Lord Alan Sugar …

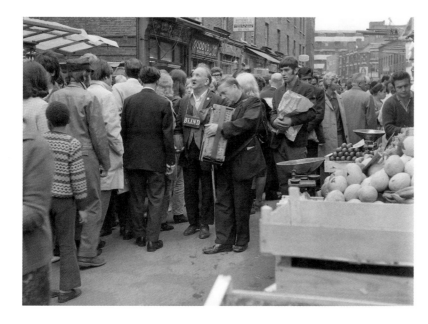

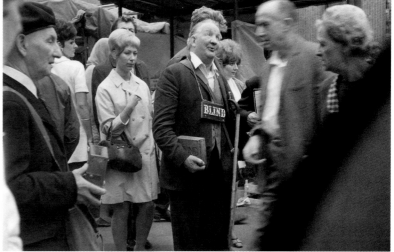

Above left and right: Where there's a crowd, street entertainers are sure to find it; here, a singing blind man set up with his musical accompaniment and his bottler busy rattling the collection box.

Right: Shellfish, jellied eels, fruit – selling to the hoi polloi the time-honoured, old-fashioned way since the 1750s.

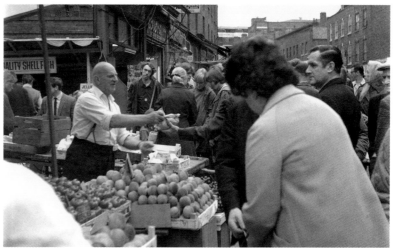

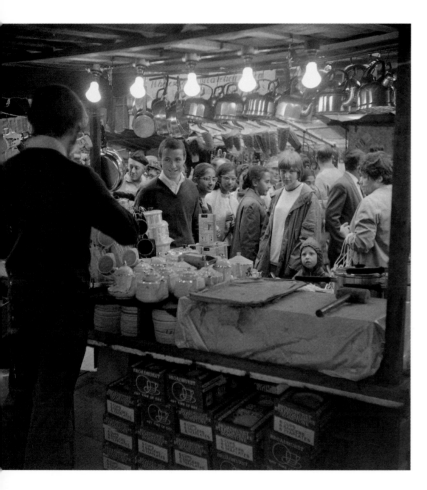
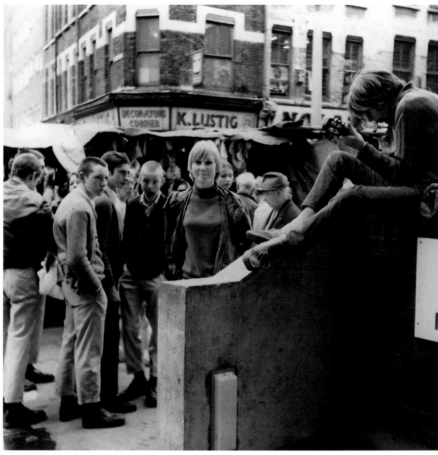

Above left: Household goods – a look behind the scene to the swirling bargain hunters.

Above right: A young entertainer attracts his own admirers, and bovver boys were never far away …

The Civilised Way of Undercover Shopping

Burlington Arcade was built in 1819 by Lord George Cavendish as a novel way to prevent rubbish being thrown into his garden at the side of Burlington House, now home of the Royal Academy of Arts. The arcade became known for 'the sale of jewellery and fancy articles of fashionable demand, for the gratification of the public'.

Uniformed beadles were employed in order to discourage unruly behaviour. Even today they can still, and have the authority to, eject anyone who 'runs, carries large packages, opens an umbrella, whistles, hums or sings'.

I was once directed to Burlington Arcade when requiring a new bulb for an outdated transparency projector after I had searched at all the usual outlets. The friendly assistant thought for a moment, then rummaged deep in a drawer below the counter and rose again triumphantly with the correct item.

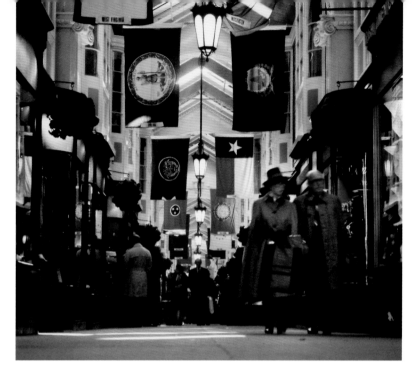

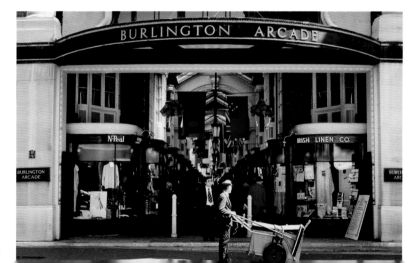

Above: An evocation of opulence.

Right: The northern exit of Burlington Arcade.

The Selling of Dreams

The practicality of real life and the dreams on offer behind the glass screen. Everything is geared to make you want something. To make you envious. To buy. This is Cork Street, but it could be anywhere in the West End. It's like holding a mirror up to reality.

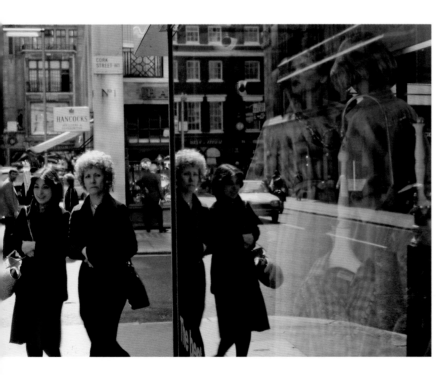 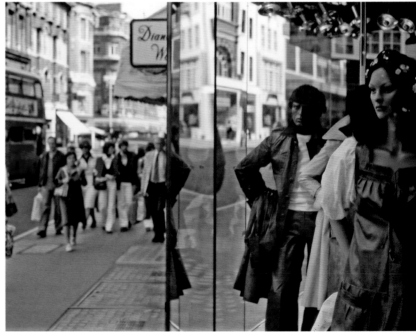

Dream and Reality in Regent Street

The lure of the mannequins: you can look like this! Without a polarising filter, the reflections add the street scene to the artificial settings of store windows. I like the mixing of the two worlds of reality and temptation.

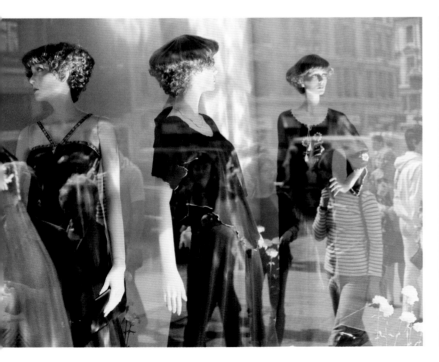
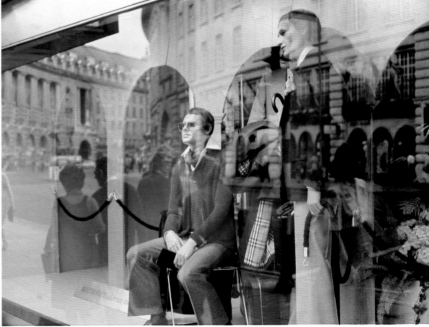

Left: Style and Opulence at Liberty's

Arthur Liberty's 1875 store began on Regent Street, selling exotic furniture and fashion. It's now in a remarkably memorable mock Tudor building raised in 1924 from the timbers of two ships, HMS *Impregnable* and HMS *Hindustan*. (The Great Marlborough Street frontage is reputed to be the same length as the *Hindustan*.)

It's an institution celebrated for great design and luxury. When our workload became too mundane and ordinary I'd love to just walk about exploring the emporium of the heavily Arts and Crafts influenced 'House of Liberty' – to stare, but not necessarily to buy.

On one occasion I hastened to assist a heavily laden lady shopper in a two-piece Worsted suit by opening and holding a heavy glass door for her. After passing she turned around and proclaimed to the world, 'Thank you. You are the last English gentleman.' I did not have the heart to disappoint her with my accent.

Right: Before the Rich Bitch Campaign

Furs still spelled luxury, but times were changing. In the 1980s, the anti-fur campaign really took off with David Bailey's 'Dumb Animals' poster and a cinema commercial making the wearing of fur quite unacceptable.

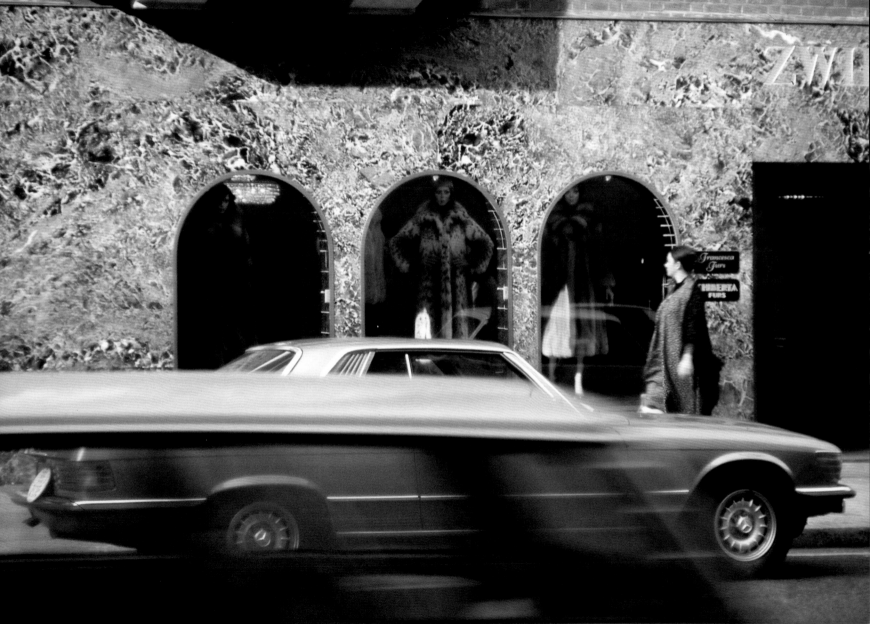

Celebrations in Regent Street

The flags were out in Regent Street for the Queen's Silver Jubilee in June 1977, although the actual accession had been on 6 February 1952. Looking north to the BBC's Broadcasting House and the slender little spire of All Souls church in Langham Place.

Below: Originally laid out by John Nash, all buildings in Regent Street are listed and protected with at least a Grade II status. In 1977 the ornate and partly concave building on the near left was still part of the Liberty store.

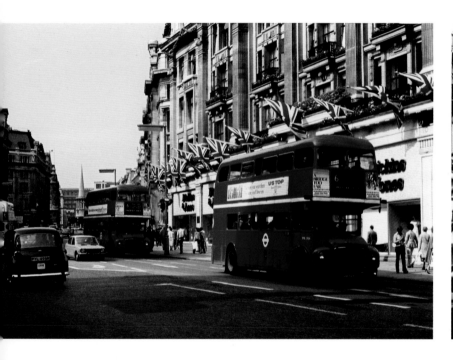

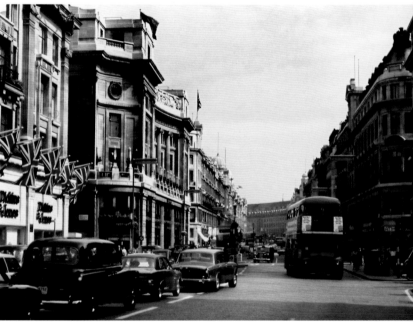

Bond Street, New and Old

Meticulously presented, Bond Street fashions contrast with the reality of life and pedestrians.

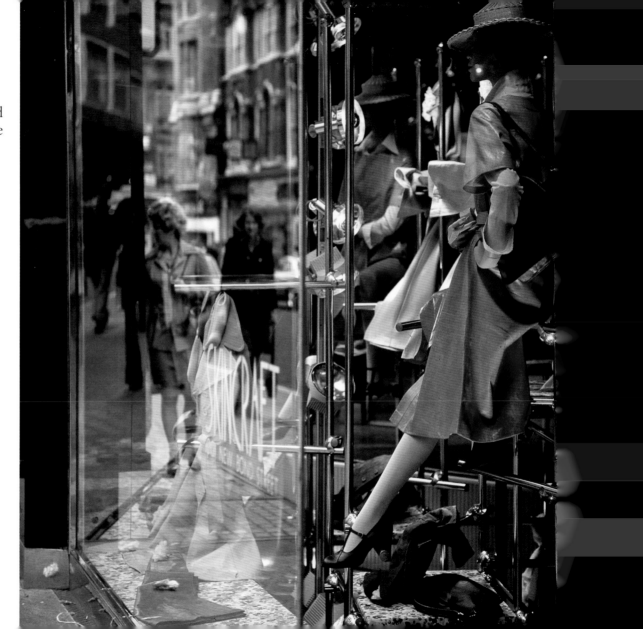

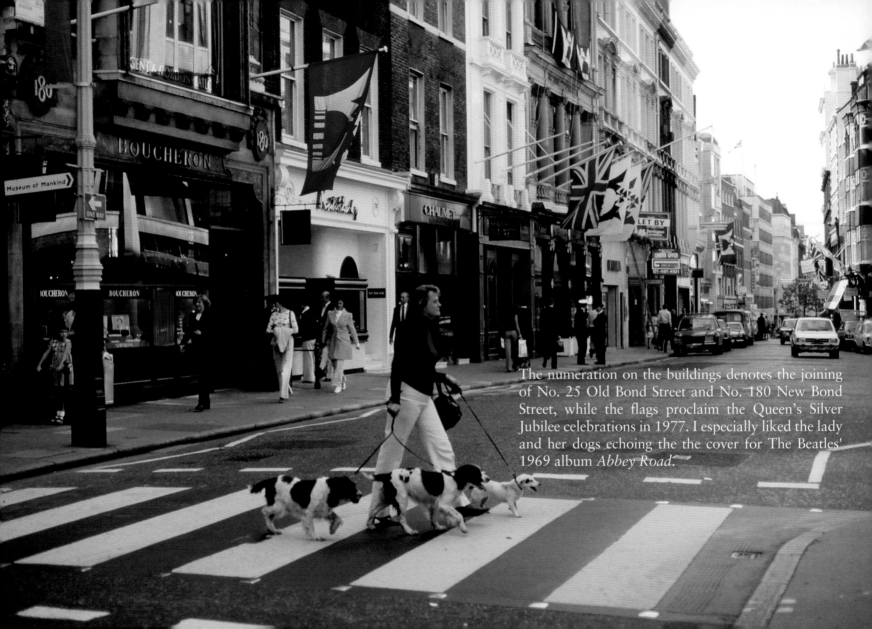

The numeration on the buildings denotes the joining of No. 25 Old Bond Street and No. 180 New Bond Street, while the flags proclaim the Queen's Silver Jubilee celebrations in 1977. I especially liked the lady and her dogs echoing the the cover for The Beatles' 1969 album *Abbey Road*.

Whoever coined the phrase 'If you have to ask the price you can't afford it' probably went shopping in Bond Street.

Left: The London Academy of Modelling offered 'the latest techniques of fashion showing, TV advertising and photographic modelling'. Former models taught etiquette, make-up and how to walk with stacks of books on your head.

Below and opposite: Bond Street shop windows celebrating the Queen's Silver Jubilee.

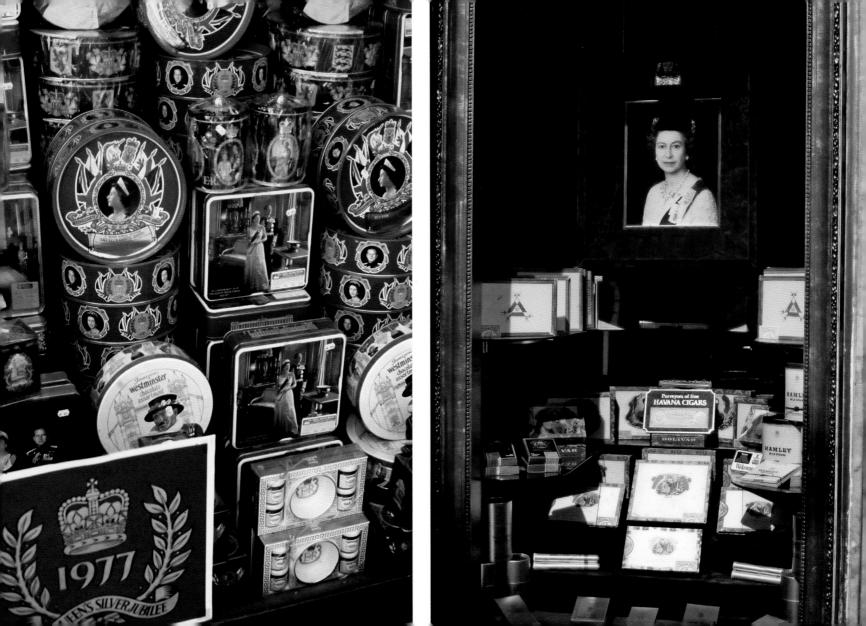

Oxford Street, Too, Brought out the Flags in Abundance

Left: Well dressed and with bulging shopping bags, queues of shoppers patiently await the next bus under a florally and royally decorated canopy.

Below: 'Loyal Greetings' from Debenhams all along Oxford Street.

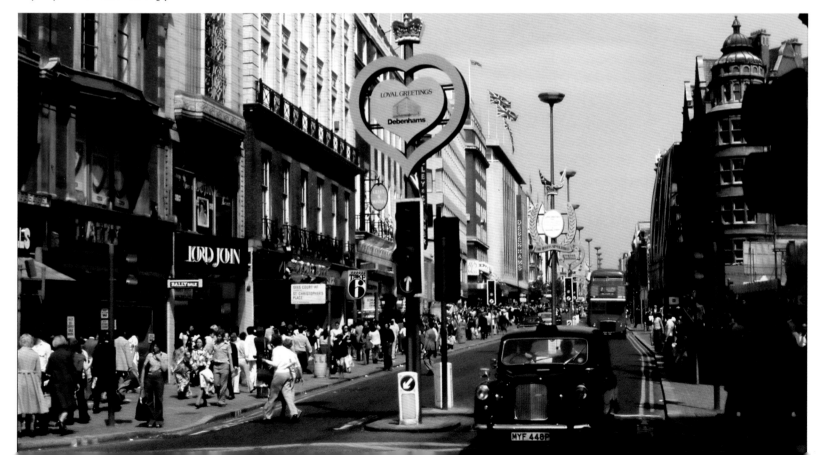

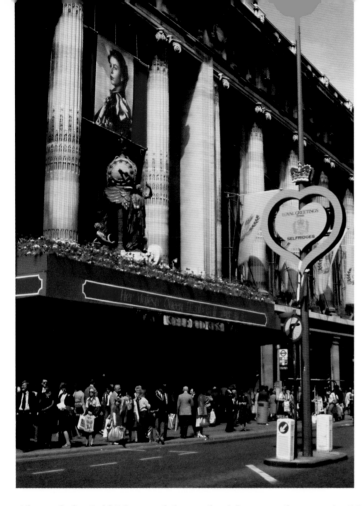
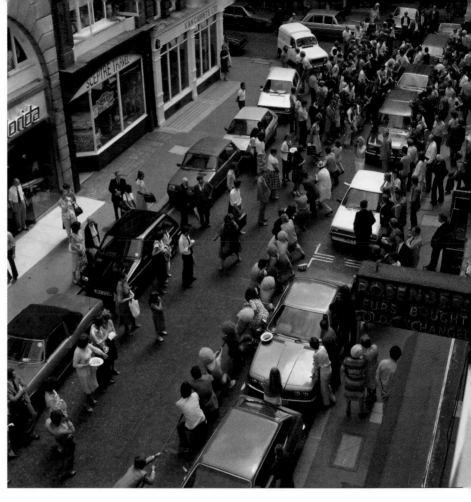

Above left: Selfridges celebrated with a royal portrait. Here the queue seems to be largely waiting for taxis.

Above right: Below our windows in normally tranquil Woodstock Street a sudden invasion of pink-wigged young ladies managed to get the 'locals' involved in an impromptu royal tug of war, refreshments awaiting.

Above: A Young Queen and an Old Lady

Royally and loyally the Old Lady of Threadneedle Street, better known as the Bank of England, was decked out in honour of Her Majesty in June 1977, while traffic vied patiently to navigate Bank Junction. The bank has occupied that spot since 1734.

Below: The Hotel Guest's View

Looking south-east from the twenty-third floor of the Hilton London Metropole. Chapel Street NW1 runs bottom centre to left, while Edgware Road passes to the right. Opposite and foreground centre, the Kings Arms Hotel is now a Costa Coffee shop.

Edgware Road owes its almost 2,000-year-old long, straight design to the days when it was a part of the Roman Watling Street, leading north from Londinium.

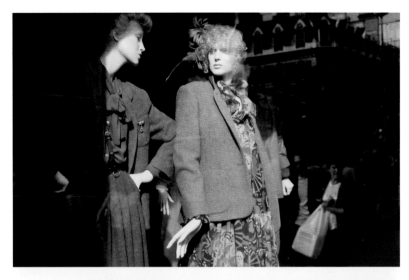

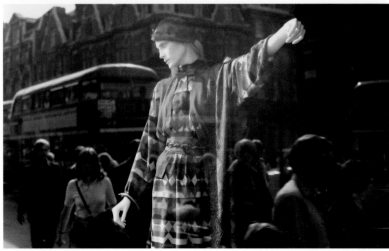

Left: Reflections on Oxford Street

Mannequins seem to be in conversation at Miss Selfridge. What could their favourite topic be? In 1987 a romantic comedy fantasy film actually brought such a model to life.

A Market for Meat, Game, Poultry, Fish – and Harry Potter

Established in the fourteenth century around a manor house with a lead roof in the centre of what once was Roman London, Leadenhall Market still had a little of the feel of a Victorian market in the 1970s, where pheasants, quail and rabbits, unplucked and unskinned, dangled on racks to entice the gastro enthusiast, not necessarily in the most hygienic conditions.

In 1666 the market was destroyed in the Great Fire, but it rose again as a covered market in the City of London, off Gracechurch Street.

Cobbled floor surfaces and green, maroon and cream environs. Sir Horace Jones's 1881 wrought-iron-and-glass structure with its cafés, restaurants, butchers, cheesemongers and florists was and is not only beloved by the Monday to Friday commuters to the air conditioned office towers that today surround it, but also by dreamers and filmmakers. Sanitised and pictorially enhanced today, *Harry Potter and the Philosopher's Stone* has found it since these pictures were taken.

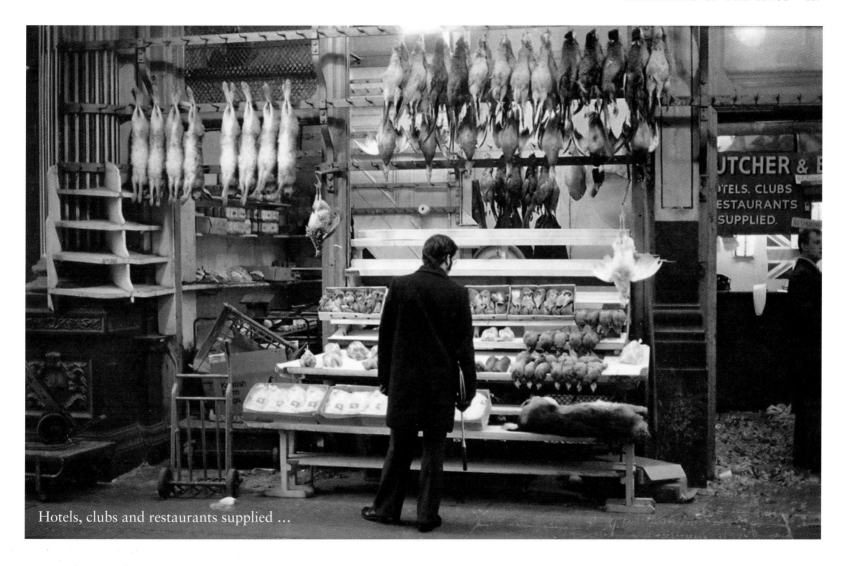

Hotels, clubs and restaurants supplied ...

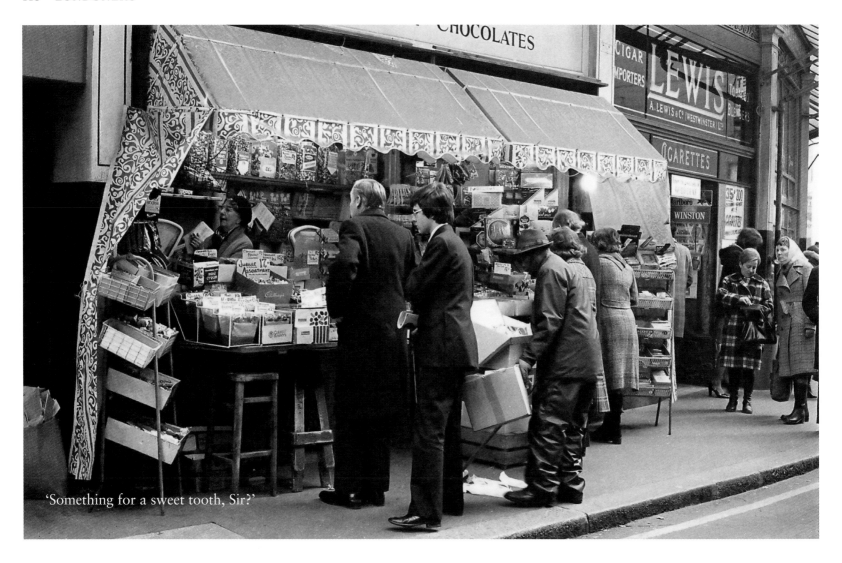

'Something for a sweet tooth, Sir?'

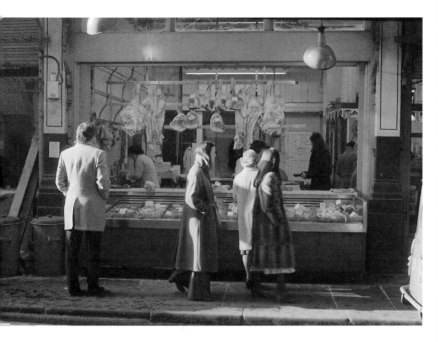

Above: Leadenhall butcher's shop.

Right: Leadenhall cheese shop.

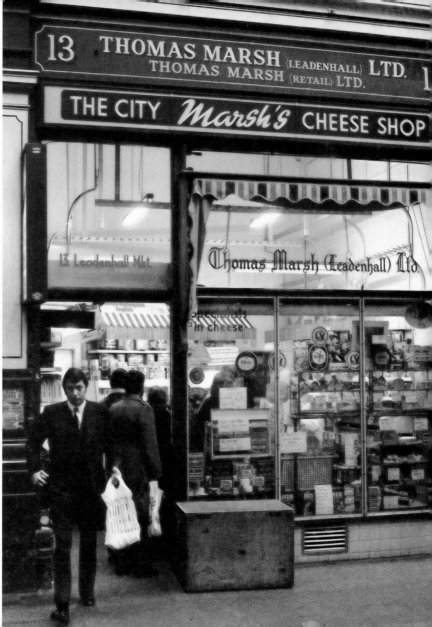

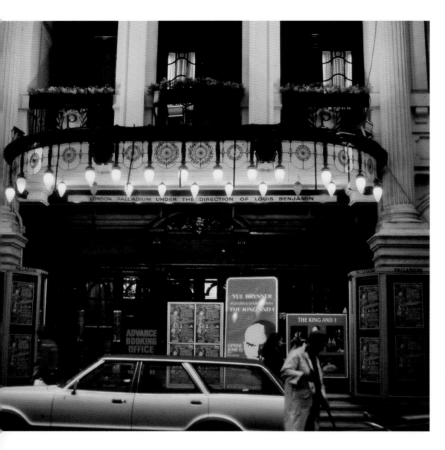

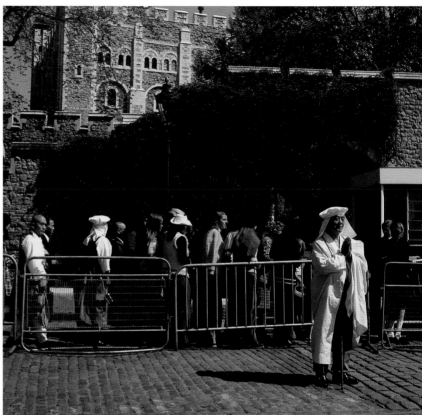

London Entertainment

The London Palladium – from Danny la Rue to the *King and I* with Yul Brynner, which opened 12 June 1979.

No sooner did the gentleman notice my camera than he took up his immaculate pose. Queues are a part of life in London, here for the Tower and the Crown jewels.

More Monumental Murals

Right: Stephen Pusey's Earlham Street Mural, Covent Garden, 1977. A community improving their environment.

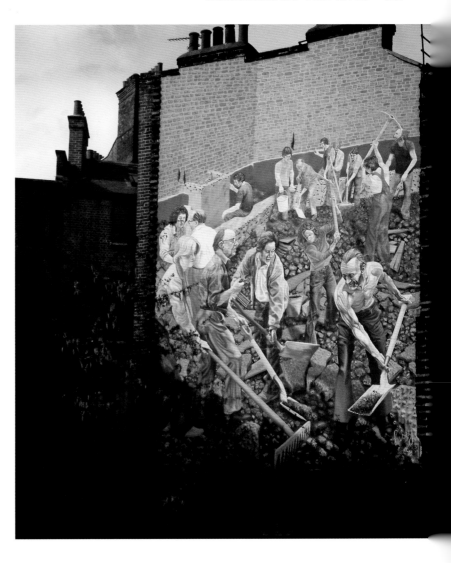

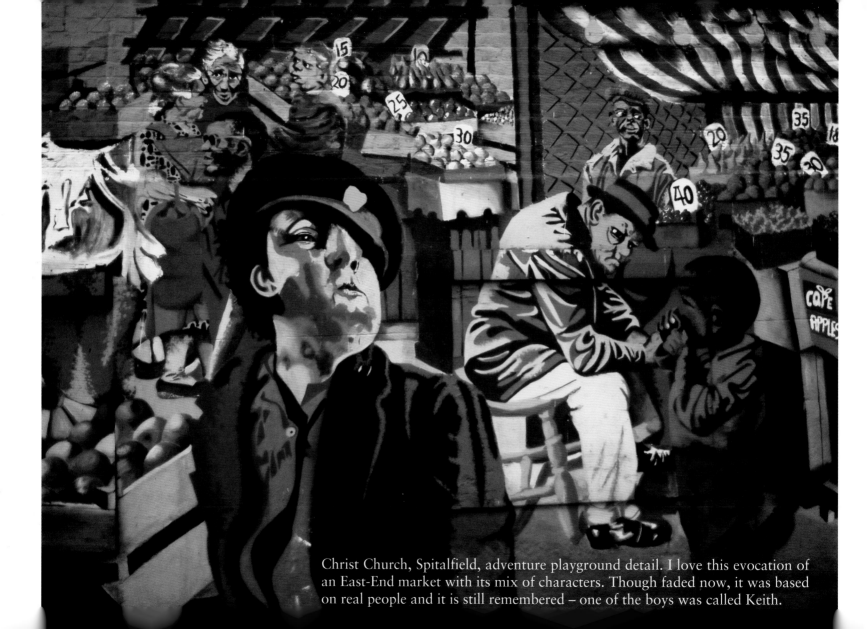

Christ Church, Spitalfield, adventure playground detail. I love this evocation of an East-End market with its mix of characters. Though faded now, it was based on real people and it is still remembered – one of the boys was called Keith.

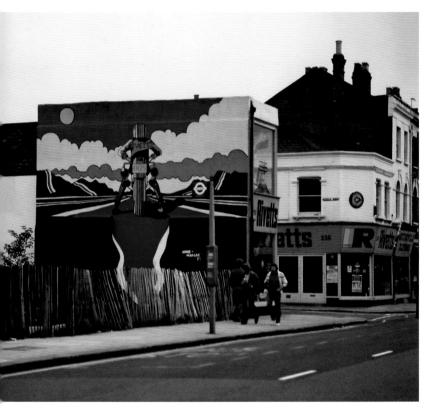

Above: Commercial mural at No. 234–6 High Road, Leytonstone.

Right: Shepherd's Bush skateboarders.

Whitbread Shires

To the country boy transplanted into the big city, one of the most heart-warming sights on the streets of London was the horse and most of all the dour, powerful, patient and good-natured shire. Until 12 September 1991, the shires of the Whitbread Brewery still clip-clopped the tarmacked highways delivering their particular sustenance to inns and taverns of the capital, though no longer in wooden casks and on soft pneumatic tires. I had seen the nostalgic sight about town, so I sought permission to accompany a delivery trip. Whenever the drivers arrived at a likely spot for a photograph I'd jump off and get in position, or if possible they would stop in a good setting.

 'We don't need a driving license to drive about town with horses,' I was assured. They had become a tradition since Samuel Whitbread first established a brewhouse in 1742. In 1897, dedicated stables were built on three floors in Garrett Street, EC1. Special ramps took horses up two floors. At one time there were more horses active in London than people. In 1912, Whitbread's head horse-keeper alone was responsible for 420 horses in various locations about London.

Right: In 1991 the last shires left the Garrett Street stables for their retirement home on a hop farm in Kent. The dappled-grey pairs in my pictures were Mercury and Mars and Gilbert and Sullivan. Efficiency won, but London is the poorer for their loss, though they still return to pull the Lord Mayor's coach at the City's Lord Mayor's Show.

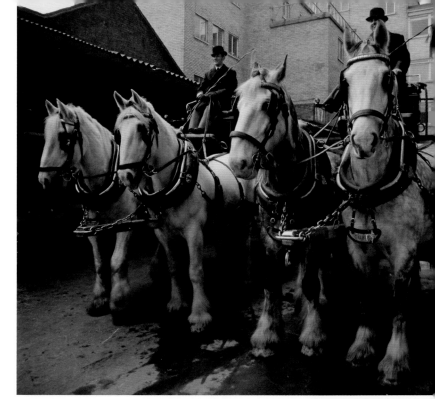

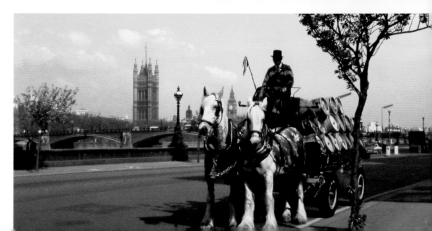

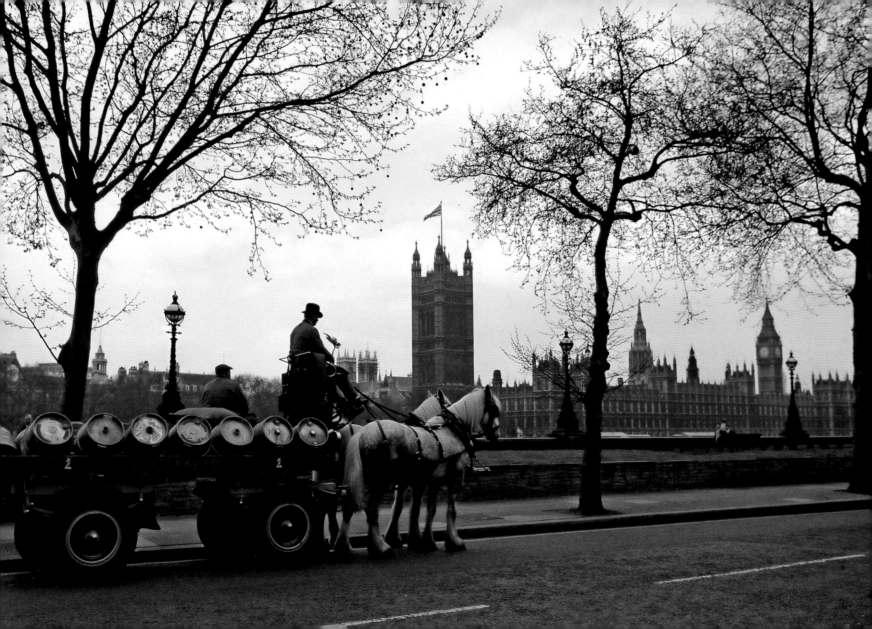

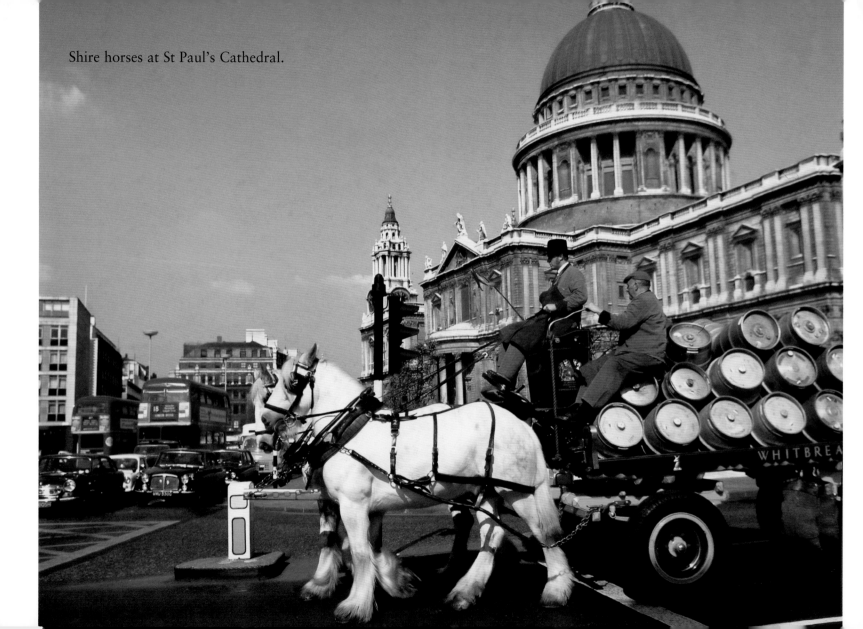

Shire horses at St Paul's Cathedral.

Christmas Decorations in Regent Street

Over the Christmas period, the main shopping thoroughfares vie for our attention and visitors come to town not only to shop but also to marvel. Here in Regent Street the theme was the Twelve Days of Christmas. 'On the third day of Christmas my true love sent to me three French Hens …'

Advent in Trafalgar Square and Goodwill to All (c. 1975)

It was a typical damp evening in London's Trafalgar Square. While in Oxford Street and Regent Street the festive sparkle of the Christmas decorations attempted to outshine the glaring neon adverts and streetlights, my part of Trafalgar Square was quite dark and deserted. A giant imported Scandinavian spruce over in the north-east corner had been re-erected among the alien surrounds of the metropolis, then romantically bedecked from top to pavement slabs with electric lights. Such a tree has been presented to the people of London by the city of Oslo each year since 1947 'for their assistance during the years 1940–45'.

Given the drizzle and the hour, there was still a crowd of people attending that end of the square, where a well-shawled choral group did their best to liven up the occasion and drown out the sounds of London with traditional carols. A noble attempt under the circumstances.

To me the lack of comfort was welcome. Wet surfaces glisten and add atmosphere in reflected light. It wasn't only the fountains that would reflect, but the very ground – the cobbles and flagstones as well.

I set up my tripod and camera for the long exposures necessary in the difficult-to-measure low light, while trying to shield the lens from the moisture of the night.

In London, perhaps especially on a night like that, there is always an element of awareness of one's vulnerability as an easy target for anybody intent on mischief. So it was with some sense of alarm when quite close to me an officious voice asked in no uncertain sarcastic tones, did I not know that tripods are not allowed in Westminster? I did not understand immediately; I was not in anybody's way. There was no one else about – well, not close enough to be inconvenienced – and I was not harming anybody or anything. I felt like an artist – unappreciated. Reassuredly, the stern voice belonged to a policeman of a stature only slightly taller than myself. I could just about make out a face under the dark dripping rim of his helmet as I reiterated my philosophy of not harming or inconveniencing anyone.

I was inconveniencing him.

I am glad I don't remember all the details of that struggling, banal conversation with a closed mind. With luck, I was producing works of art that all and everyone could enjoy, I said. Advent and Christmas were such emotive and atmospheric times. What with the tree and the choir and the iconic surroundings I was going to record a culturally elevated side of London and the tripod was essential in the low light.

At first he tried to be reasonable. Someone might fall over my tripod.

There was nobody else in the vicinity.

That was neither here nor there. There was a by-law banning tripods in Westminster and there were no exceptions.

Could I not just finish what I was about, while he watched over me and made certain no accidents happened? I asked innocently. He could be my protector and champion of the arts.

Perhaps luckily I could not determine facial expressions, but his body language altered somewhat.

It was not his function to supervise someone breaking the law. He would make his round and would be back presently, by

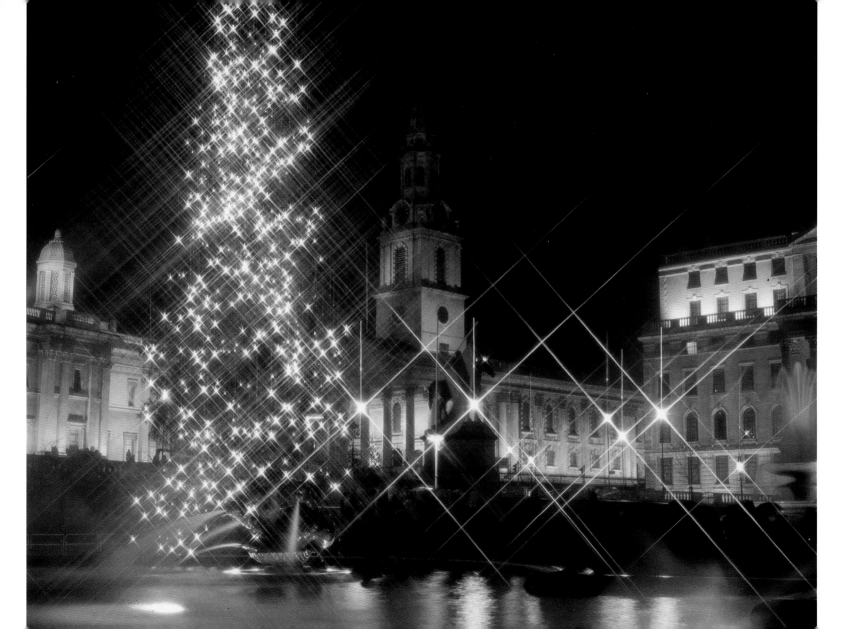

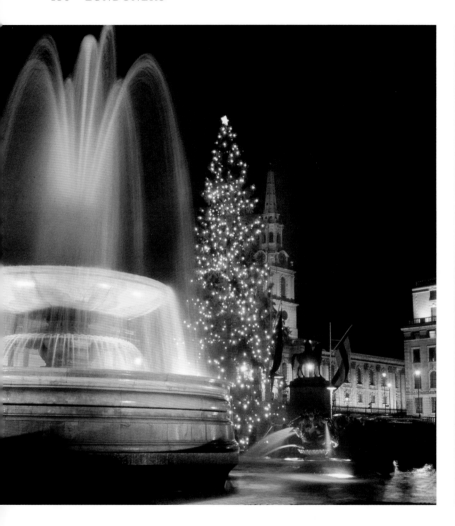
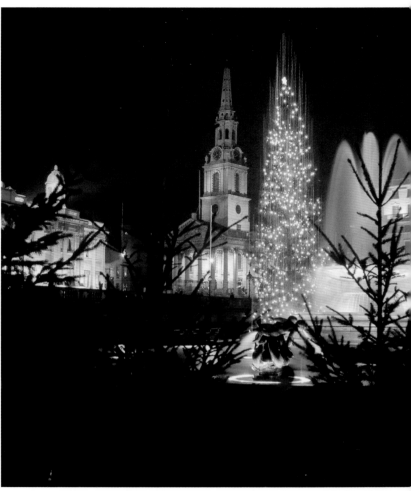

which time I had better be gone. I decided he was not smiling and began to pack up and move away.

On leaving the square I became aware of more pictorial opportunities. My art got the better of me. Thinking I was out of harm's way, I knelt down on the pavement, albeit not for long. The officer must have made a beeline to come back and check on me.

Again, the long arm of the law threatened me with dire consequences if I persisted in ignoring its directive: 'Are you taking the p***?' he asked, finding me now kneeling on the cold, wet but reflective surface of the square surround, the camera resting on the stones, front supported by anything steady I could find to raise the lens for a conducive shot. The ostracised tripod lay folded down by my side, an obstacle, I confess, to anyone who had the temerity to stumble close by me.

'But I'm not on the square anymore'. I made one more feeble excuse: 'I'm on the pavement surrounding it.'

That did not cut any ice with my accuser at all. In fact, it led to a stream of expletives.

'If you persist in flaunting the law I'll have to take you in.' It was going to be detention for trying to produce a masterpiece.

'Okay,' I said, 'I'm just about done here, anyway.' I packed my gear together, wiped off the rain, and left the scene of the crime.

Looking back over my shoulder and in the shadows away from the light-festooned Scandinavian tree, I noticed my adversary tarrying, just in case I might change my mind. Still, with all the cards and publications the resulting images have graced, it was well worth the trouble.

London in Snow

The Houses of Parliament from Southbank. London is always a few degrees warmer than its surroundings, and it is rare that snow turns it into a winter's scene, though I do remember a day when its white glitter even covered and lingered on trees – a day when I was without my camera.

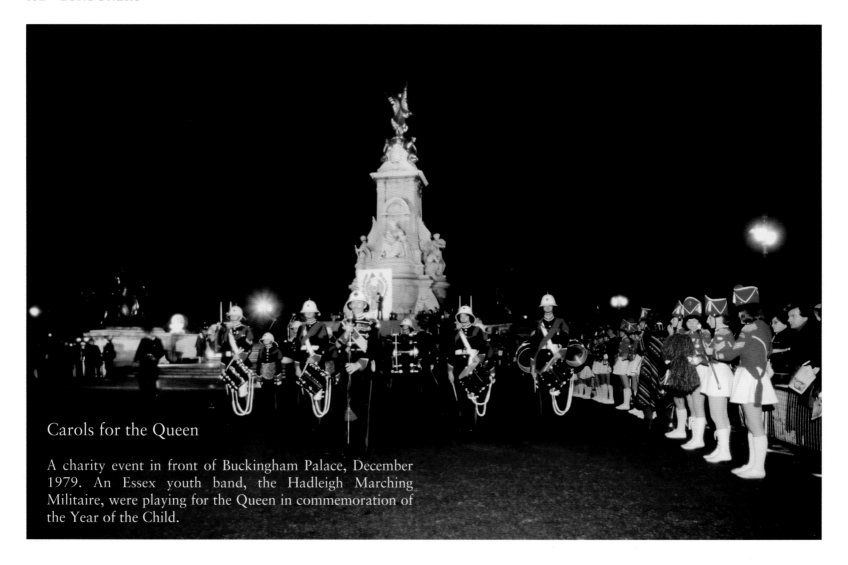

Carols for the Queen

A charity event in front of Buckingham Palace, December
1979. An Essex youth band, the Hadleigh Marching
Militaire, were playing for the Queen in commemoration of
the Year of the Child.

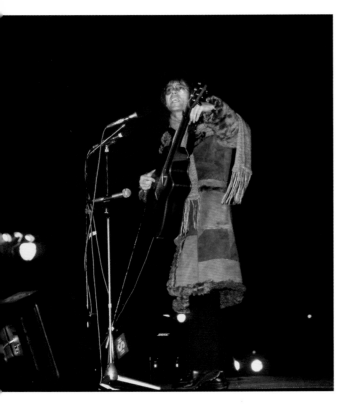
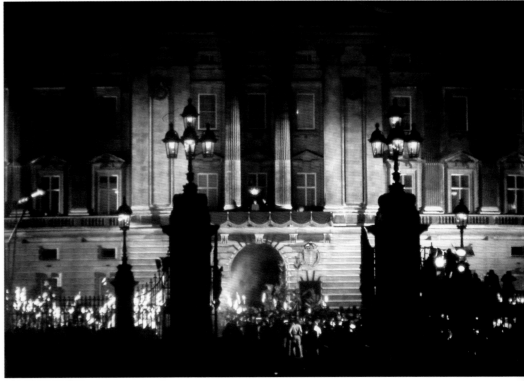

Above left: Cliff Richard at Buckingham Palace, December 1979. The bands marched and played and Cliff sang carols, all in aid of a children's charity.

Above right: Torch Parade at Buckingham Palace, December 1979.

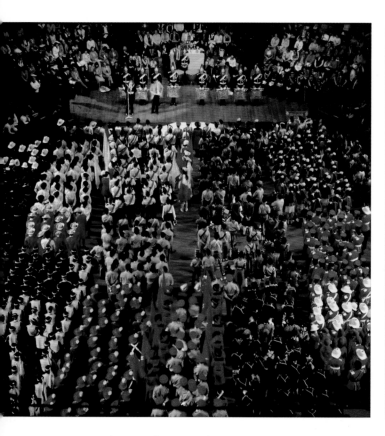

National Youth Marching Bands Championship

Above left: Massed assembly of the National Youth Marching Bands, Royal Albert Hall, 1979.

Above right: 'ByeBye'. Members of the Hadleigh (Essex) Marching Militaire at the Royal Albert Hall, 1979.

3

MEMORIES OF THE 1980S

The swinging sixties turned into the sober seventies, which morphed into the self-centred eighties. In one sense the 1980s were the domain of two women: Britain's first – and to date only – female Prime Minister and a shy young woman who became a princess. Under Margaret Thatcher council houses were sold off, the Falklands were reclaimed from Argentina by force of arms, coal miners were defeated in the coalfields and trade union powers were curbed. Being freelance, the shenanigans of the London arm of the Printers' Union had little impact on me, though for a while it looked as if we would have to join up.

Brixton had its riots, the Greater London Council (GLC) was abolished and the IRA carried on bombing.

Near the end of the decade Margaret Thatcher's Poll Tax caused the population to riot as it had done at the Peasants' Revolt in 1381, though not as ferociously. This time it meant Margaret Thatcher's downfall in 1990.

Early this decade the big airlines finally succeeded in killing off the upstart Laker Airways, the long-haul, low-cost, no-frills airline, by undercutting its fares. It cost around £100 to fly to Hong Kong and back by British Airways. I flew and photographed all over the Far East.

As manufacturing declined in London, so banking and financial services grew. The derelict docks were transformed into Docklands' offices and residential districts. Referring to the old warehouses and alleyways on the south side of what used to be the Pool of London, 'Find them before the developers do,' advised an advert on the Underground.

London's fruit, vegetable and flower market Covent Garden had been removed south of the river to Nine Elms, Wandsworth, so early this decade it was refurbished and transformed into shops and attractions like the London Transport Museum.

In July 1981, the wedding of Prince Charles and Lady Diana Spencer put the spotlight on London with the ceremony in St Paul's Cathedral. An estimated global TV audience of 750 million watched the 'fairytale wedding'. Princess Diana, the 'People's Princess', became a fashion idol. (It was reported that 'Lady Di' blouses were 'run up by the mass market and were selling like hot cakes'.)

The couple separated eleven years later and divorced in 1996.

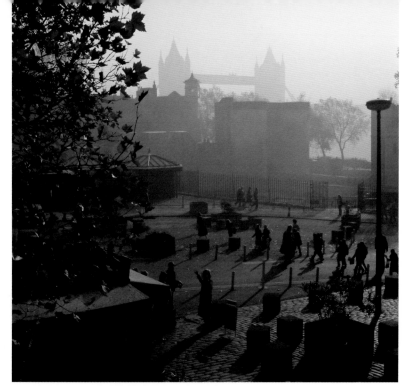 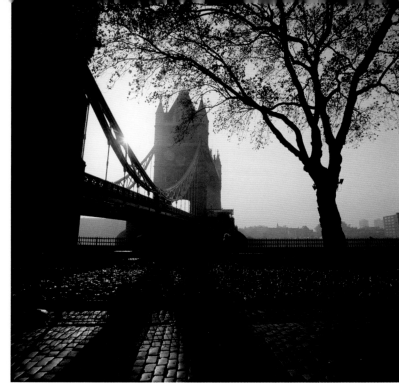

Tower Hill and Tower Bridge

Above left: A misty autumn morning by the river, sun glistening off well-worn cobblestones. If only they could speak. Here everything exudes tradition and history, of time standing still even though Tower Bridge is only a late Victorian addition. The tourists still arrive. Guides explain their history. Entertainers try to turn passers-by into audiences – the musician or the escape artist fighting his way out of a tied sack while being constrained with chains and locks that secure hands, feet and body. Breaking free seems impossible. The language is reminiscent of the music halls, bear-baiting and Victorian feats of strength.

Above right: Others find that melancholy place fascinating, with time to just stand and stare.

King Charles II's Finger

The Monument on Monument and Fish Street commemorates the Great Fire that started in a bakery in 1666. The fluted Doric column was erected in the 1670s by the architect who also designed St Paul's Cathedral, Sir Christopher Wren. Allowing a 360-degree view over London, it drew in the public, though it also appealed to those unfortunates who find it impossible to deal with life. Six people threw themselves to their death from the gallery, three of them bakers or relations of bakers. Following the last, a servant girl who committed suicide in August 1842, the gallery was enclosed in an iron cage.

Exactly 311 steps take us to a height of 62 metres (202 feet), the height equaling exactly the distance to the point in Pudding Lane where the fire had started. I climbed the 311 steps, prudently leaving my weighty camera case downstairs with the curator, only to realise too late that there was only one image left on the film in my camera. I lacked the stamina to attempt a second ascent.

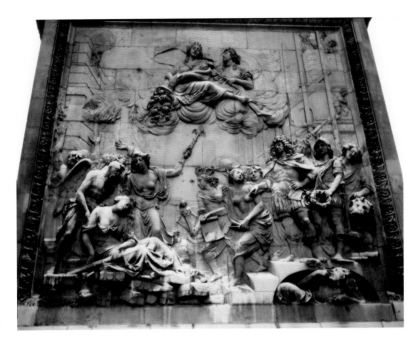

At the base of the Monument on the west side a bas-relief attempts to tell something of the story of that dreadful fire. King Charles II and his brother James, Duke of York, later James II, in the company of liberty, architecture and science give direction for London's restoration. The Monument has since been cleaned and repaired. No longer does it seem that King Charles's finger on his outstretched hand casually marks an eternally feminine point of interest; the repaired hand today again innocently holds a scroll, no doubt of some architectural merit.

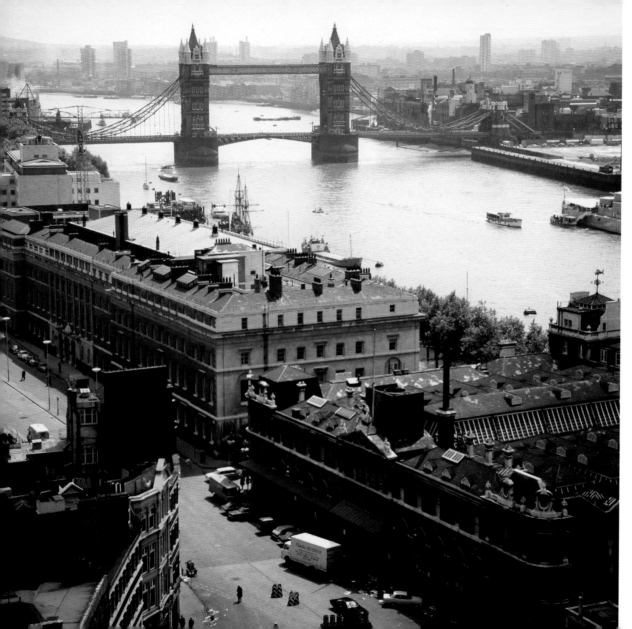

Left: River view from the Monument.

Opposite: Tower Bridge with a dramatic sky. How the banks and the buildings around it have changed with the passing years.

Built in 1886–94 to facilitate a new river crossing, the new bridge had to allow tall ships access to the Pool of London. The solution was a combined bascule and suspension bridge that can open and raise its bascules to facilitate passing river traffic as in salute. The colour scheme of red, white and blue was added for Queen Elizabeth II's Silver Jubilee in 1977.

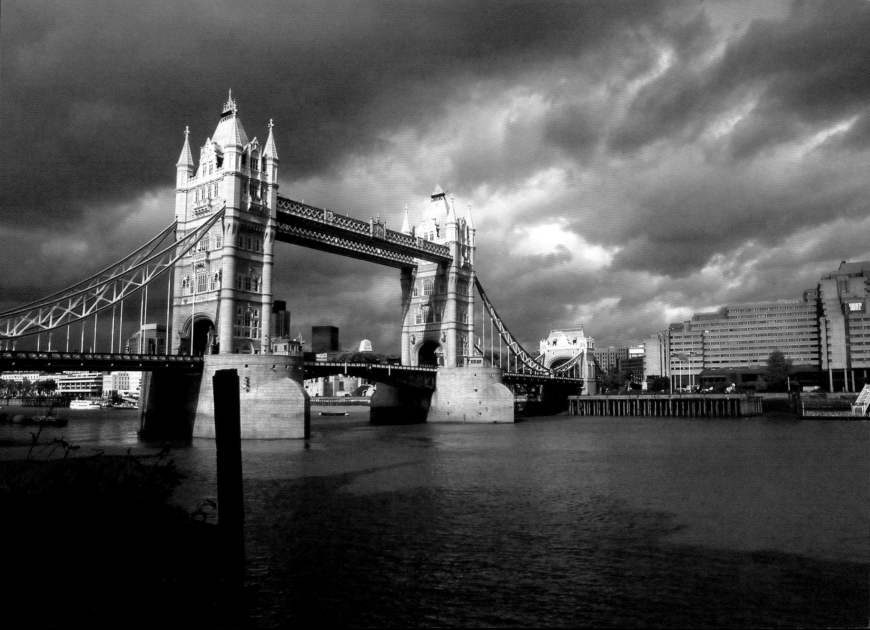

Carnaby Street Area

The little, soon to be pedestrianized, street in Soho, close to both Oxford and Regent Street, became a venue for numerous boutiques in the early 1960s, attracting both the mod and the hippy style followers for their 'gear'. It quickly became the coolest place to be when London was 'swinging', with designers like Mary Quant inspiring and popular pop bands popping by from nearby underground music bars. Its fame was such that in Germany a pop song extolled its appeal by hinting at but not explaining what and why 'was so alles geschieht in der Carnaby Street …' ('whatever happens in Carnaby Street …').

Top right: By the time I took these photographs, the once-fashionable location had lost some of its lustre. It was no longer cool and had given way to commercial opportunism. The young lady in the centre wears a Lady Di blouse with the wide v-shaped lace top.

Bottom right: Lithe footwear like pumps and pedal pushers in white, with winklepickers on the racks.

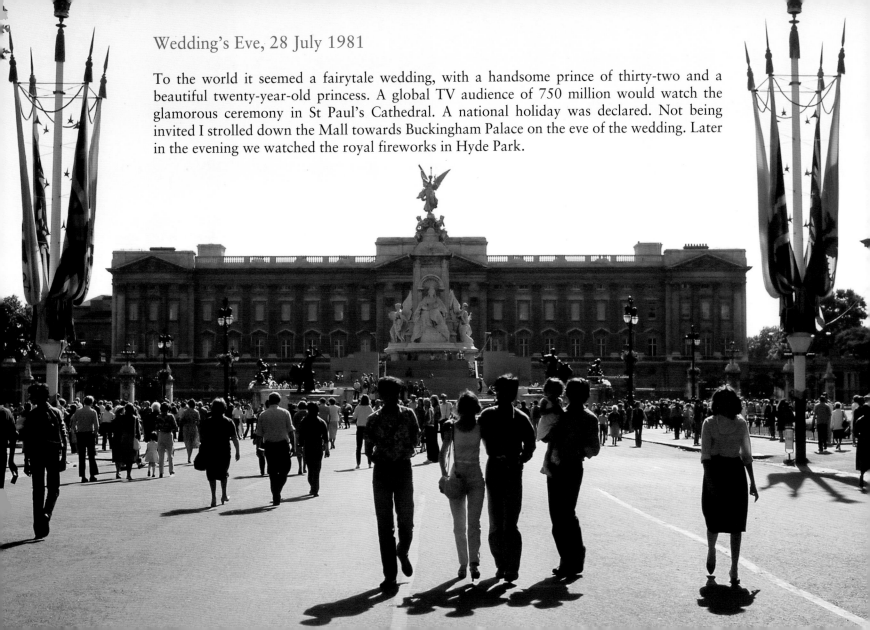

Wedding's Eve, 28 July 1981

To the world it seemed a fairytale wedding, with a handsome prince of thirty-two and a beautiful twenty-year-old princess. A global TV audience of 750 million would watch the glamorous ceremony in St Paul's Cathedral. A national holiday was declared. Not being invited I strolled down the Mall towards Buckingham Palace on the eve of the wedding. Later in the evening we watched the royal fireworks in Hyde Park.

Camden Lock and the Markets

People-watching can be a great and entertaining pastime. I loved to go out and watch different lifestyles and attitudes to life. All human life is here, the ostentatious and the quiet observers, the brash and the peacocks. Quite often the subjects of my camera actually loved to be photographed. A market can be one such place, but I have also been sent packing on occasions. In 1985, before it was so drastically transformed, it was still a somewhat unkempt and gritty place to hang out.

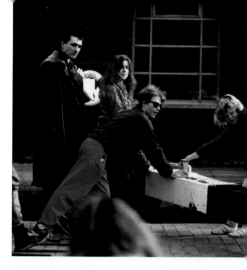

Top right: It wasn't all for show. The young folk entertained themselves and heartily lent a hand when a boat passed through the locks and a canal gate needed muscle to be opened or shut, whether waterborne passengers might or might not need help operating the heavy beams for their passage.

Bottom right: To see and be seen. Camden Lock offered a gritty, self-evolved, almost natural opportunity.

Opposite: Expressing her personal style and selling her home-made basques and spiked attire under a corrugated iron roof, lovingly supported by a doting mum, this young entrepreneur would be an absolute magnet to photographers.

Left: Whatever the environment, a pizza might just be affordable.

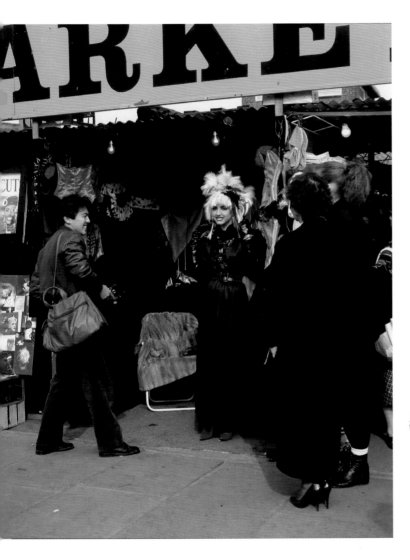

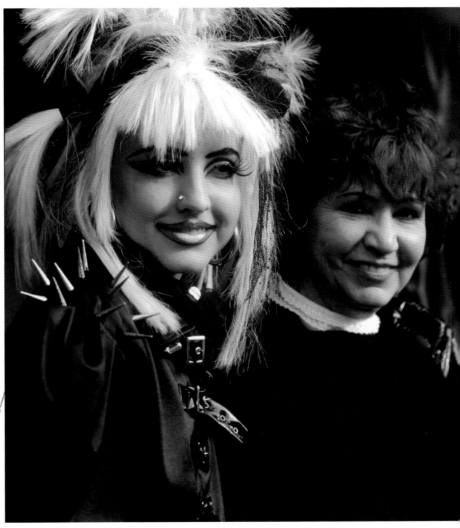

Wide-Angle London

Right: A cleaned-up Piccadilly with an advertisement for *Starlight Express* (1984). Eros had been moved south, out of the centre and is now part of a pedestrian precinct. Some of the advertisements have been removed and the buildings cleaned, so we can again appreciate the beautiful architecture of the original façades.

Below: The view up Cornhill, with the Royal Exchange to the left, the domed No. 1 Cornhill dominating the centre and St Mary Woolnoth church to the right between Lombard Street and King William Street.

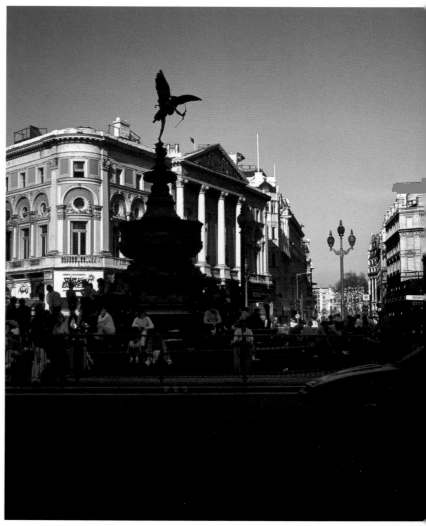

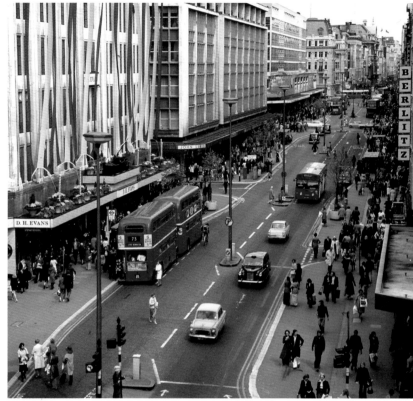

Street Views

Above left: View from a window in Queen Anne Street with the 'secret' Post Office Tower difficult to avoid.

Above right: View from a window looking east on the tree-lined shoppers' paradise of Oxford Street.

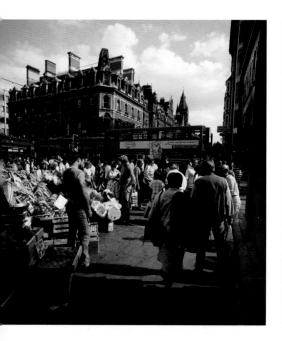 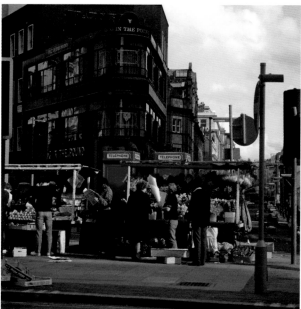

In and About Oxford Street, W1

Above left: August 1987 and the pavement beside Selfridges has been turned into a fruit and flower stall.

Above middle: Serving the tourists. Oxford Street, view down Davies Street, with South Molten Street to the left, the 'paved zone' in front of the Hog in the Pound public house.

Above right: Just off Oxford Street, cafés spill out on to the pavement at the corner of Duke Street and Barrett Street, August 1987.

 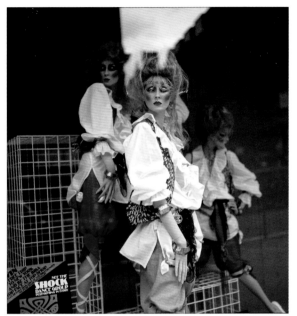 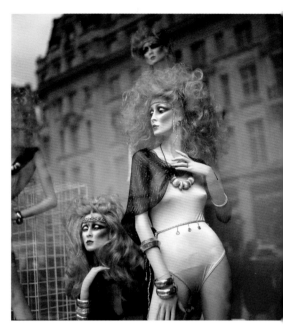

Above left: Amid concrete benches and concrete tubs with wispy young trees, entrepreneurs would set up their easily collapsible trestle tables and sell jewellery that was bought in African or Middle Eastern bazaars during winter months.

Above middle: Daring, outrageous and colourful fashions at Oxford Street's Topshop, early 1980s: 'See the Shock Dance Group performing in-store and enter a competition to win a free trip to New York and become the Biba – Topshop face!' For a short while the Biba logo became one of the best-known fashion brands.

Above right: As Alice in Wonderland would have said, 'Curiouser and curiouser'.

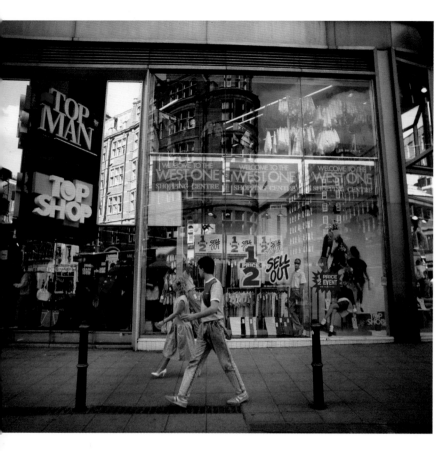

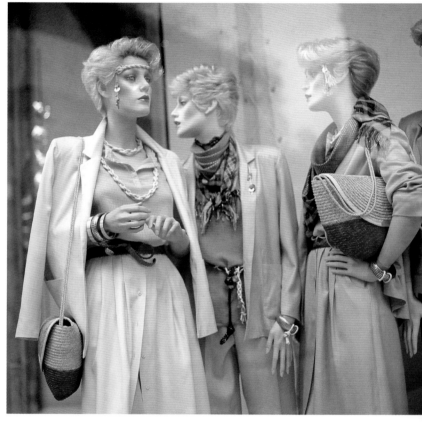

Above left: Boy watches girl and the girl ignores both him and the tempting half-price offers. Topman and Topshop on the corner of Oxford Street and Davies Street.

Above right: What is the collective noun for a group of mannequins? A gaggle of mannequins? A meeting of dummies? A stable of clothes horses?

Above right: Flowers and Knights

Charm was back in fashion as displayed here on the Pontefract Castle in Wigmore Street, WC1.

Below right: Ealing Broadway

Being well aware that most of my views were found in the West End or in the City, sometimes I would just travel out somewhere and look for photographs. Here, with the glorious background of Christ the Saviour parish church, Ealing Broadway, a healthy lifestyle is on offer at a typical barrow. Apples and oranges, bananas and greens confirm the wholesome picture. Plastic carrier bags proclaim the royal wedding of Prince Charles and Lady Diana Spencer of 29 July 1981.

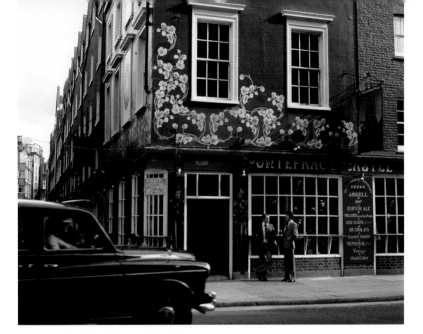

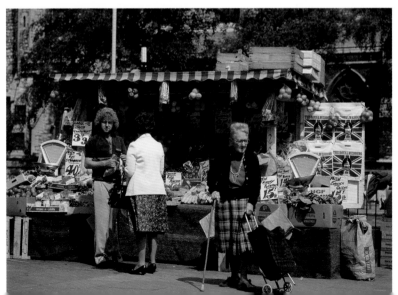

 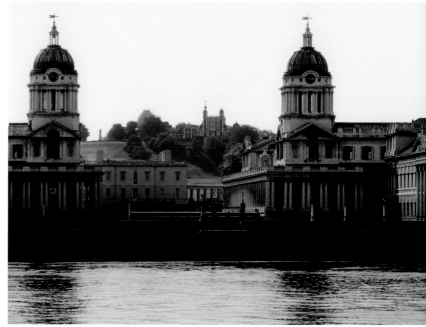

Greenwich and Its Observatory

Above left: The Thames at Greenwich. In the foreground a ladies' crew of the Globe Rowing Club take a moment's rest. The view is upriver from the towpath in front of the Old Royal Naval College, now Greenwich University. To the left the Old Greenwich Pier has since been replaced by a new construction. Deptford Power Station on the opposing bank has not survived.

Above right: In the background the Royal Observatory dominates the hill with the prime meridian as a line in the lawn, down by the waterside Greenwich Hospital. Designed by Christopher Wren as the Royal Hospital for Seamen, it became, for a time, the Royal Naval College. UNESCO described it as being of 'outstanding universal value'.

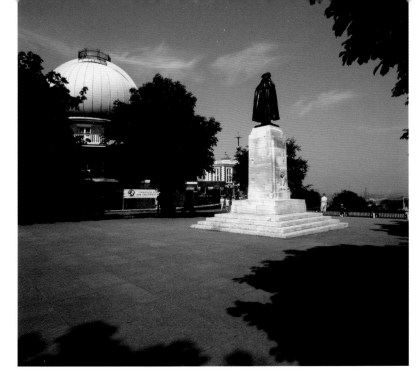 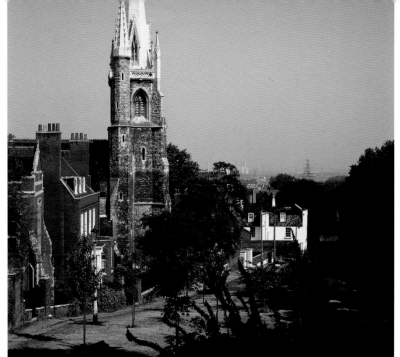

Above left: The banner celebrates a hundred years of Longitude Zero, 1884–1984. There is a subtle difference. What used to be the Royal Greenwich Observatory, commissioned in 1675 by King Charles II, is now the Royal Observatory, Greenwich. While it remains the location of the prime meridian of longitude, which arbitrarily divides the Earth into two hemispheres, its actual scientific work has since been relocated and it is now a museum. A white line in the lawn and the brass strip in the courtyard have since 1999 been given added impact by a laser beam pointing north across London's night sky.

Prominent in this view is a statue of local man General James Wolf (1727–59), a man who paid with his life for a great victory over the French at Quebec. History is everywhere in London, here erected in 1930, a gift of a grateful Canadian people.

Above right: The spire of a Greenwich church with the beautiful name 'Our Ladye Star of the Sea' looks down on the *Cutty Sark* and across the river on a constantly changing London skyline. Completed in 1851, the church catered for Catholic seamen, mainly Irish, Brazilian, Indian and Portuguese.

A Transformed Garden

It used to be a convent garden when it belonged to the Benedictines of Westminster Abbey. Henry VIII gave it to the Earls of Bedford. Inigo Jones designed it as a residential square, though none of those houses remain. Charles II established it as a market. By the 1700s the area had deteriorated and attracted taverns, theatres, coffee houses and brothels. The government stepped in and market buildings were erected. The market kept growing until 1974 when it was relocated to Nine Elms. The flower, market is the London Transport Museum now. Over time, and with the casual treatment of language, the Convent Garden became Covent Garden.

Where there are markets there will be entertainers, and several spaces for musicians' and entertainers' performances have been set aside and included in the new tourist-friendly layout. There are thirteen theatres in the wider area and some sixty pubs and bars.

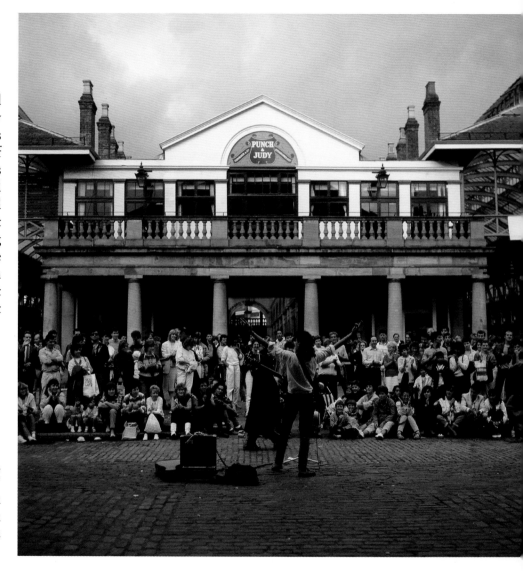

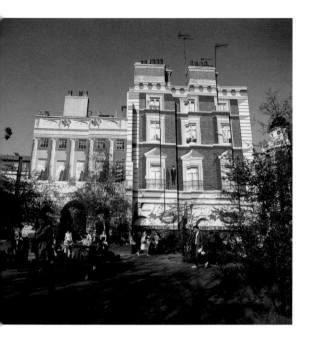

Above left: Surreal homage to Magritte in 1982. A *trompe l'oeil* mural by Ken White adds a curiously noble background to a pleasant garden setting.

Above middle and right: Graffiti was everywhere during the clearance and alterations of Covent Garden. I thought the young ladies admirably suited the environment.

Cremorne Gardens, Chelsea and the Albert Bridge

In Victorian times afternoons might be quite genteel here, when stout ladies in wide layered crinolines and darkly clad gents in stovepipe hats could watch something as innocent as a maypole dance. Evenings would be quite different. On Derby Day, 31 May 1865, for instance, at six o'clock, the 'Great Sea Bear or Walking Fish' (a common seal to you and I) will be exhibited and you can be astounded by the 'Aeriel Flights by Signori Costello'. At ten o'clock, 'Professor Sinclair, the Wizard of all Wizards and renowned Ventriloquist will introduce the most startling Wonders of the Age in Necromancy, Legerdemain, Prestidigitation and Ventriloquism'. At 11 o'clock there will be fireworks followed by Signor Bueno Coré, 'the Great Original Fire King', who will 'enter a Blazing Furnace and Coolly Promenade therein …'

Among other entertainments were tightrope walks across the Thames from Battersea by a daring young lady and feats of jumping from balloons with improvised parachutes or maybe even the more deadly attempts at sailing (or dropping) down on home-made wings.

'Dancing will continue till the close of the Gardens'. That's where the owner's problems came in. What else went on in the shadows and shady grottos in the gardens was greatly concerning many respectable citizens who feared for the morality of the revellers and were trying to shut the gardens down. Times changed and in the 1870s they finally succeeded.

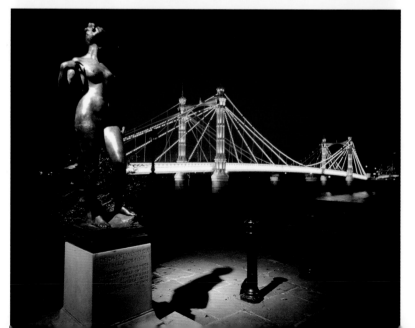

Opposite above: The day was closing, the sun sinking low. The ladies in their colourful saris had left and only these two gentlemen were still engrossed in their game of backgammon as they might have been on the banks of some Far Eastern river. I asked their permission and requested that they carry on and ignore me. The tranquil and high-rise background setting can be found at Chelsea by the side of the Thames, Cremorne Gardens, once the much larger Cremorne Pleasure Gardens, Cheyne Walk Embankment.

Opposite below: Francis Derwent Wood's 1907 statue *Atalanta*, virgin huntress and fleet runner, follower of the goddess Artemis in Greek mythology, gazes distractedly at the river and a rather pretty but not entirely safe bridge. A suspension bridge from the early 1870s, it has undergone several attempts at strengthening. Some 4,000 bulbs light up Albert Bridge at night, though not all of them are working.

Nights in the City

Left, the Corinthian columns of the eighteenth-century Mansion House, official residence of the Lord Mayor of London, with holding cells where suffragette Emmeline Pankhurst once suffered confinement.

Centre, where Queen Victoria Street and Poultry meet. Poultry, before the Great Fire of 1666 noted for its proliferation of taverns, is one of the several reminders of a time long gone when poultry stalls collected here as part of the Cheapside Market. Other such reminders of the past include Milk Street, Bread Street, Fish Street, Cornhill, Shoe Lane and Pudding Lane.

In the centre, the wedge-shaped Mappin and Webb building, now No. 1 Poultry, has since 1997 been replaced by a zebra-striped edifice of peculiar design with a turret that has been likened to a submarine's conning tower and attracted the uncertain distinction of having been voted the fifth-worst building in London by *Time Out* magazine.

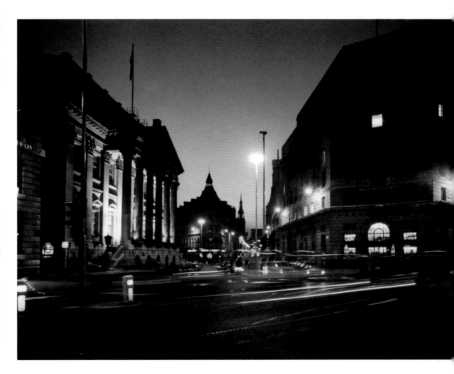

Day and Night at Selfridges

Mr Selfridge's store in Oxford Street cannot be ignored. It is Grade II listed, but its classical looks are deceiving; they hide a steel frame. Built in sections, the first half opened in 1909, employing 1,400 staff. There was a world war and the second phase opened in 1929. Beneath its lower shop floor are two more basements, part of which were used in the Second World War by the US Army Signal Corps once America entered the fray. So close to the American Embassy, at one time General Eisenhower operated from here.

Nights could be eerie in the City with few humans about in the canyons the roads have become among the tall, stone edifices. On my frequent late nights, such walks were not unusual.

Here at Mansion House Street (EC2) we have the imposing façade with elevated pillars of a NatWest building illuminated on several floors. A blue plaque informs us that prison reformer Mrs Elizabeth Fry (21 May 1780 – 12 October 1845) once lived on the site.

Across St Mildred's Court the building marked by the shaded figure now occupies the site of St Mildred's church, which was demolished in 1872.

Without a tripod the camera would be wedged against suitable buildings or street furniture for the long exposures required.

Opposite left: Oxford Street magic at late evening Christmas shopping. The main entrance in Oxford Street under its colourful, golden-skinned angel and the clock has been described as Europe's busiest doorway through which 250,000 people pass each week.

Opposite right: Shoppers, buskers, demonstrators, religious chanters, pickpockets, protest buses … Oxford Street is like an artery through which much humanity flows.

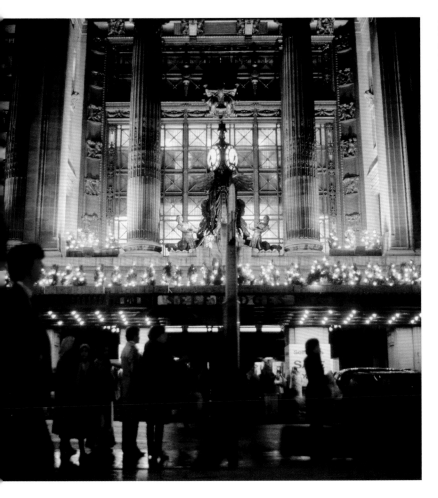

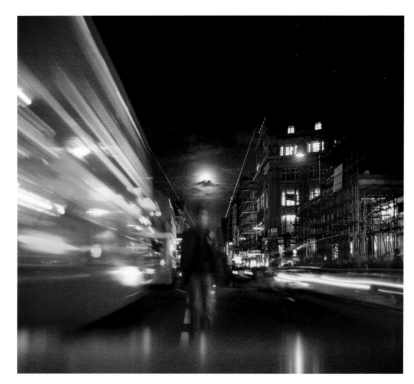 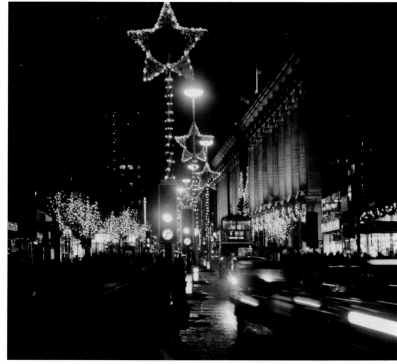

Christmas in Oxford Street

Above left: During Christmas 1987 it was decided that instead of furnishing the expense of the annual Christmas decorations it would be rather exciting to send laser beams the length of Oxford Street to help entice the shoppers in. The innovative, yet finally unexciting and austere experiment has not been repeated.

Above right: Cars, buses, crowds, twinkling lights: this was an Oxford Street Christmas with Selfridges.

CHANGES: THE ONLY CONSTANT

It's no good actually going back and visiting old remembered scenes if you want to keep your memories intact. The Victorian warehouse turned into an artists' and artisans' enclave, where I worked for many years, was built so sturdy that I thought they'd never be able to shift it. Sometimes, while all was quiet when working through the night to keep deadlines, one could hear and feel the Underground trains rattling by in the bowels of the earth below. In the 1970s, when Irish Republicans caused death and destruction in the country, not least in London, police advised us to evacuate the premises once because of suspected bombs in the neighbourhood. I had such confidence in those thick Victorian walls, I was too busy to stop and I stayed on. Even that strongest of buildings has been dug up and out and replaced by something so modern it is unrecognisable.

Two floors below us, the basement used to be home to a once-fashionable nightclub, the Rheingold, with surprisingly obvious Germanic associations. Hesitating by the entrance a lady once asked me, 'The nightclub, is it still as much fun as it used to be? We used to have some marvelous times here and I wonder if I can recommend it to my grandson, too.' Times had changed, but the premises had not. Having lost its sparkle, it had opened for luncheons, but it was so dark in there one could barely see what was served.

More recently I walked into a spaghetti restaurant just off Oxford Street.

'Can I help you?' I must have looked lost.

'Can you tell me how long you have been here?'

'What? In here or in de country?'

'No, here, this place? It used to be "The Bonbonniere"'.

'Ah, the Bonbonniere. That was seven years ago they moved out,' in a strong foreign accent I couldn't place. She nodded affirmation. Waiters were queuing up behind me. The place was busy. Space was at a premium. All was modern and gleaming with as many seats crammed in as possible, stainless and spotless

and artless. The bar was new, too, but the basic space was the same – an L-shape that disappeared around the far corner and had another rarely used exit to that side. Heavy curtains used to separate the space normally at breakfast time, when there were fewer customers. For the lunchtime crowd the curtains would be pushed back. The curtains had gone.

'Sorry,' I said, 'We used to come here at lunch hours for years, sometimes for breakfast …'

She nodded politely, still friendly, but her eyes wanted to be somewhere else.

'Thanks,' I grinned and left before I became a nuisance. On Thursdays they used to serve Ossobuco.

'Next customer, please.'

It's All about Memories

We met at the Clachan, a well-remembered hostelry in Kingly Street, between Liberty and Regent Street.

'How old are you now?'

'I am eighty.'

The white-haired octogenarian took me to a particular spot at the east side of Regent Street. 'I stood here with my gun in 1953 protecting the Queen at the Coronation. The procession came along here. I had been in the Air Force for eight weeks and I was fed up already. I was 21.'

I could well understand the highly individual and gifted former graphic designer abhorring regimentation and being told what to do without self-expression. We had been working together on many of his advertising campaigns and became friends over the years.

'You can't have stood here in 1953,' I dared intercede. 'We have just celebrated the Queen's Diamond Jubilee and that was in 2012.'

'I know where I stood and when I stood here.' I was on shaky ground, I knew. You don't tell an old soldier he is wrong, not when he was there at the time, but facts are facts. Of course he was right: the Queen came to the throne on the death of her father in 1952, but the Coronation did not take place until a year later. We became friends again when I apologised humbly to have doubted him.

'Maybe they had to wait until you were old enough to hold a gun straight …' I said.